Miró.

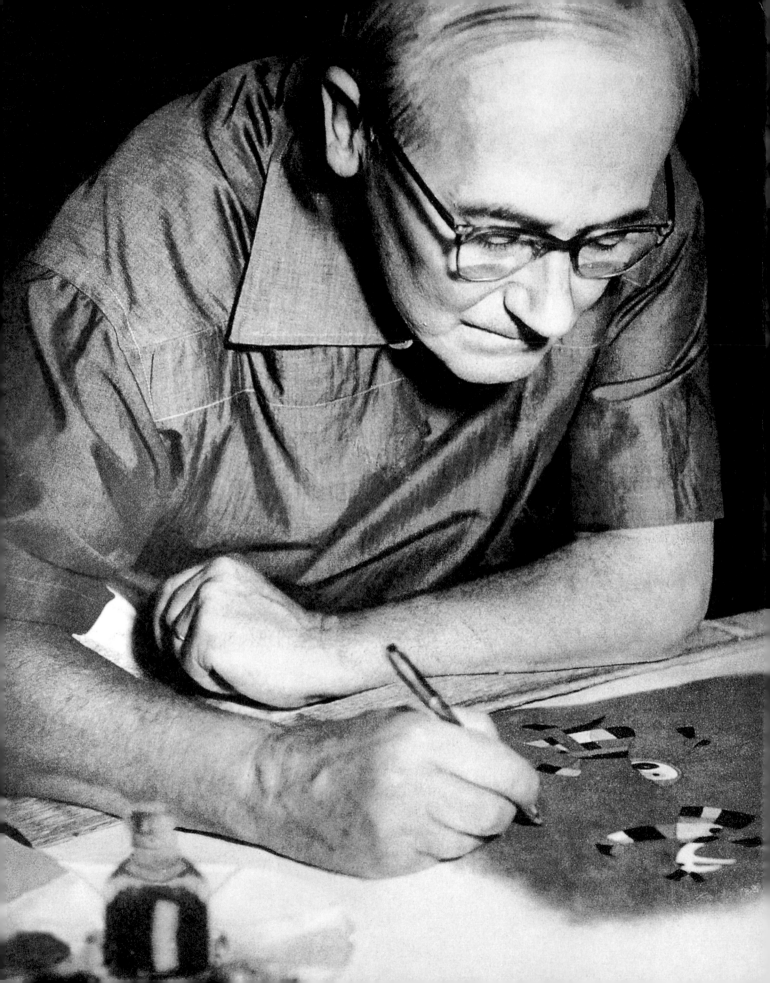

Janis Mink

Joan Miró

1893–1983

The Poet among the Surrealists

TASCHEN

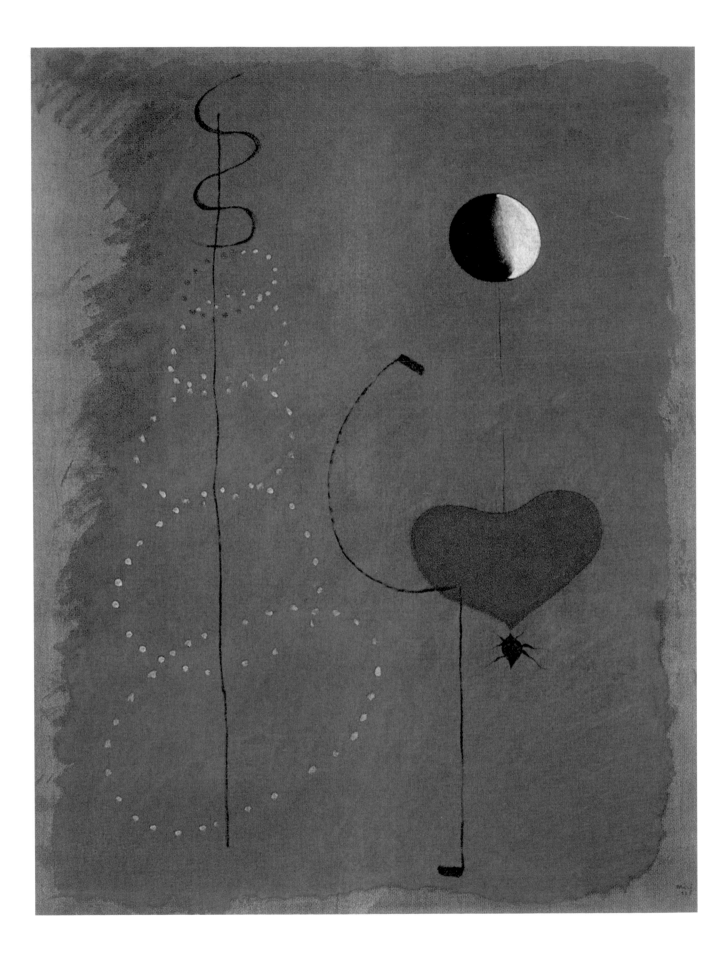

Contents

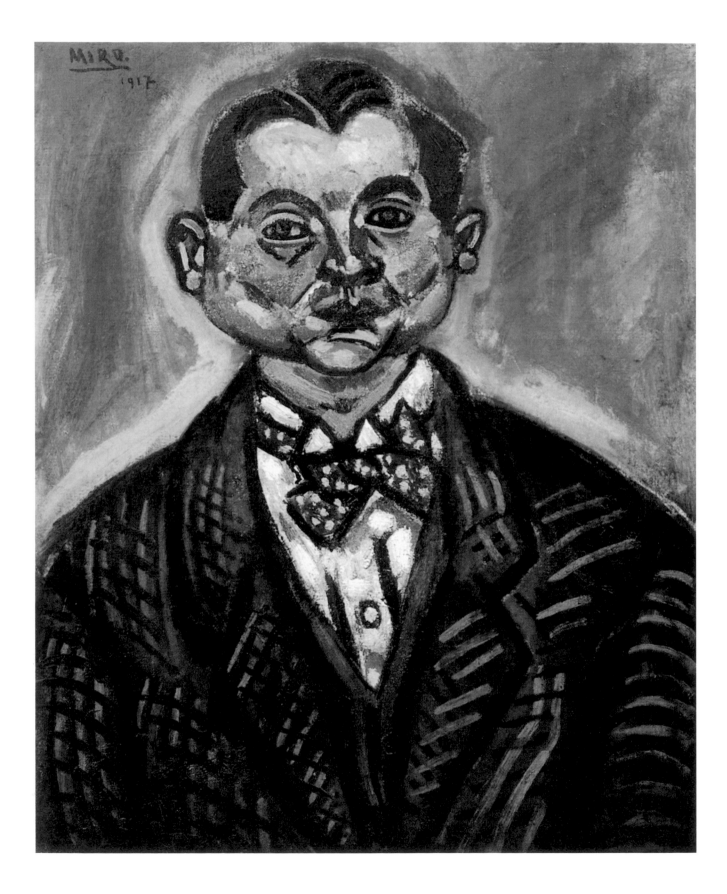

"If this is painting, then I am Velázquez"

Joan Miró became an artist under relatively hostile conditions. It was the kind of hostility that greets almost every young artist when he or she tries to resist the predictable parental suggestion of entering any respectable and safe profession. But it was also the hostility of an aged art world that had locked itself into its own academies and was getting furious at the youngsters who were starting to climb out of the windows. Born in 1893 in Barcelona, Miró belonged to a generation faced with the inheritance of the nineteenth-century "isms" that had liberated painting from its job of depicting recognizable subjects. However, by the time Miró was ready to open the door of the art world, Cubism had already disassembled and reconstructed the picture space and its subject matter and Dada had just dynamited art's meaning. The Fauves had stopped using paint to show nature, and had begun using nature to show paint. In short, the academic art world was under attack and some enemy camps had already formed. Young artists had to decide about their allegiance. Then they had to find their own artistic identities. The war going on in the art world was, in its way, a picture of the greater institutional decay and the struggle for a new order within the world's political balance. For example in Spain, the government changed 44 times between 1898 and 1923.

Joan Miró's national identity was clear to him from the very beginning, which is more than can be said for his artistic identity. He was a Catalan, not a "Spanish" citizen. His father was a goldsmith and watchmaker from Tarragona, whose own father had been a blacksmith. (Miró was named "Joan" after this grandfather.) Miró's father left his native village for Barcelona, where he switched to precious metals and built up a very successful business. Miró's mother was the daughter of a cabinet-maker from Palma de Majorca, whom grandson Joan never met. The cabinet-maker could not read or write and spoke only the Majorquin dialect, yet he managed to advance from an assistant carpenter to the owner of a successful business. He also loved to travel and got as far as Russia by train, "which at that time was really something." His wife, Miró's grandmother, was "very intelligent and

The Farmer, 1912–14
Oil on canvas, 65 x 50 cm (25½ x 19¾ in.)
Private collection

Miró's first works are strongly influenced by modern art; particularly by the work of van Gogh and the Fauves. Traces of this influence can be found in the heavy brush strokes of this early oil painting.

PAGE 6
Self-Portrait, 1917
Oil on canvas, 61 x 50 cm (24 x 19¾ in.)
New York, private collection

romantic."[1] Miró had an extremely close, if not conflict-free relationship with his family. He writes about his parents, "My mother had a strong personality and was very intelligent. I was always very close to her. She cried when she saw I was on the wrong track. But later, she took a great interest in my work. My father was very realistic and absolutely the opposite of my mother. When I went hunting with him, if I said the sky was purple he made fun of me, which threw me into a rage."[2] Although both hailed from a background of craftsmen, Miró's parents had an extremely low opinion of the profession of painting pictures ("wrong track") and kept him on a short financial leash. Miró remembers his sister fondly because she slipped him money when he "didn't have a cent to buy paints."[3]

A reserved and dreamy child of fragile health, Miró was a poor student at school. He remembered being somewhat better at geography – something flat and pictorial – than at other subjects like the practical sciences, but even in geography he let himself be guided by a second sense instead of knowledge: "Often I guessed precisely the answer to the professor's question by pointing a stick at the map at random."[4] Miró started drawing classes at the age of seven. During the very same year he began what became an annual trip to his grandparents, thus exchanging the city of Barcelona for more provincial Catalan surroundings. The inhabitants were simple farmers. His maternal grandmother lived on Majorca. Miró travelled there by ship, accompanied by a household servant; those trips taught him to love the sea. While the countryside visits were meant to help improve his health, those summer trips probably also freed Miró of a great many parental restrictions. He was a visitor, an observer, and he spent a lot of time drawing by himself. The many sketchbooks Miró saved from his youth show accurate, if unremarkable, observations of village streets and architecture, as if he were memorizing the places he saw. Later as an adult, he would continue to return to the countryside of his childhood for long periods, usually during the summer and fall.

In 1907, when Miró was only fourteen years old, the question of his future career loomed against the horizon line marked by the unsuccessful end of his secondary schooling. His father firmly suggested business classes. He attended them. But he also simultaneously attended the famous art academy "La Escuela de la Lonja," where Picasso's father had taught and Picasso himself had been briefly enrolled nine years earlier. Unlike Picasso, who had already mastered the techniques of academic painting with amazing ease at the same age, Miró was still a raw beginner showing no particular promise. He studied with Modesto Urgell Inglada, a painter of melancholy landscapes somewhat in the style of Arnold Böcklin, and José Pasco Merisa, a professor of the decorative and applied arts. The latter suited Miró's father, since he would have also liked to have seen his son become interested in the goldsmith trade. Urgell's landscapes with their wide horizons left an impression on Miró and would recur in some of his later painting. Pasco, on the other hand, taught Miró to be as free as possible in his work, to trust and follow his own inclinations. As a whole, the decorative arts were a field free of per-

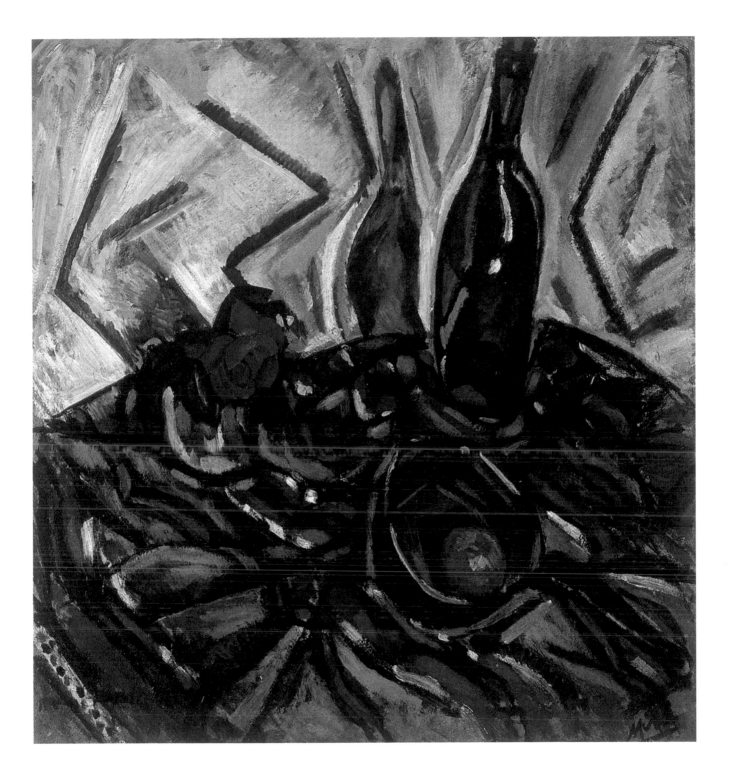

spective and illusionistic space, where Miró could relax into expressiveness. When Pasco directed his students' interest to the colorful vitality of Catalan folk crafts, Miró must have felt released from academicism into the warm pool of his love for the Catalan heritage.

After the seventeen-year-old Miró had completed his business schooling, he began a job as book-keeper for Dalmau Oliveres, a hardware and chemical company, and put his artwork aside. This led to a minor nervous break-

Still Life with Rose, 1916
Oil on cardboard, 77 x 74 cm (30¼ x 29¼ in.)
Switzerland, private collection

This still life, with its lively strokes and intensive colors, is aimed at expressiveness. Miró could have found ideas for his composition and form in the still lifes of Matisse or Cézanne.

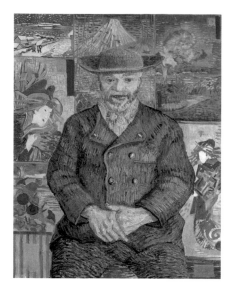

Vincent van Gogh
Le Père Tanguy, 1887
Oil on canvas, 92 x 75 cm (36¼ x 29½ in.)
Paris, Musée Rodin

PAGE 11
Portrait of E. C. Ricart, 1917
Oil and pasted paper on canvas,
81.6 x 65.7 cm (32¼ x 26 in.)
New York, The Museum of Modern Art,
Florene May Schoenborn Bequest

Like van Gogh and Monet, Miró refers to Japanese art with his portrait of his studiomate. He has incorporated a Japanese print in the background, whose delicate lines are almost crushed by the bold forms and colors of the figure. In this way, Miró contrasts and combines East Asian and modern art in one picture.

down followed by a bout with Typhoid fever, which finally convinced his father that he was not suited for business and office work. Miró later writes about this period in his life, "Fights with the family; give up painting to work in an office. – Catastrophe; do drawings on account books and am fired, naturally. At nineteen I enter the Galí Academy in Barcelona to devote myself entirely to painting. A marvel of awkwardness and incompetence."[5] The private academy led by Francesc d'Assís Galí was very progressive. Galí did not ascribe to any particular direction of modern art, but tried to create an atmosphere that would help each student on his or her individual way. A sort of anti-professor, Galí would take his students on walks in the mountains and forbid them to sketch; instead, they were supposed to use their eyes alone to burn their impressions into their memories. Music was also an important element in the school, where there was a concert every Saturday, as well as a choir. In the concerts of the Society for Chamber Music that Galí had founded in Barcelona, his students had reserved box seats. These activities brought the reserved Miró together with fellow students, several of which were to remain his best friends for his whole life. One of them was Llorens Artigas, the ceramicist with whom he would collaborate on many big projects after the Second World War.

Interestingly enough, Miró credits two of his professors with using the same method to teach him, which either means they both did, or that he fused their teachings in his mind because this method had become his most important recollection of student days. Both Pasco at La Lonja and Galí supposedly had him draw objects which he was not allowed to see. Miró would hold an object behind his back and then try to reproduce its appearance inspired by tactile impressions alone. For Miró, this was an important lesson in his battle of mastering form.[6] Although he considered himself a successful colorist, he was bitterly unhappy with the way he could depict objects. The concept of initially disregarding the way things looked seemed to sharpen his feel for what he could accept as a correct form for his composition. It kept the real look of something from distracting him. It also helped Miró to escape obedient copying and freed his power of invention, as well as strengthening his sculptural sense.

Miró's father was always checking up with Galí to make sure his son was making progress. As Galí later told Miró's biographer, Jacques Dupin, "He was a pleasant man (…) a typical Catalan businessman who was concerned with the 'deals' and material advantages of life. Every week I repeated, 'Your son will be successful, he will be a great artist.'"[7] Although Miró's family was in good financial circumstances, they did not intend to support Miró all too generously in his resolution to become an artist. Obviously, they still thought he should be financially independent of them and have some sort of profession. "In order to earn a living and paint at the same time, my family advised me to become a monk or a soldier…"[8] At that time in Spain, every young man was required to fulfill military service unless he paid his way out. Miró's father was willing to pay only part of the sum that would have entirely exempted his son. In 1915, Miró entered the military in Barcelona for an abbre-

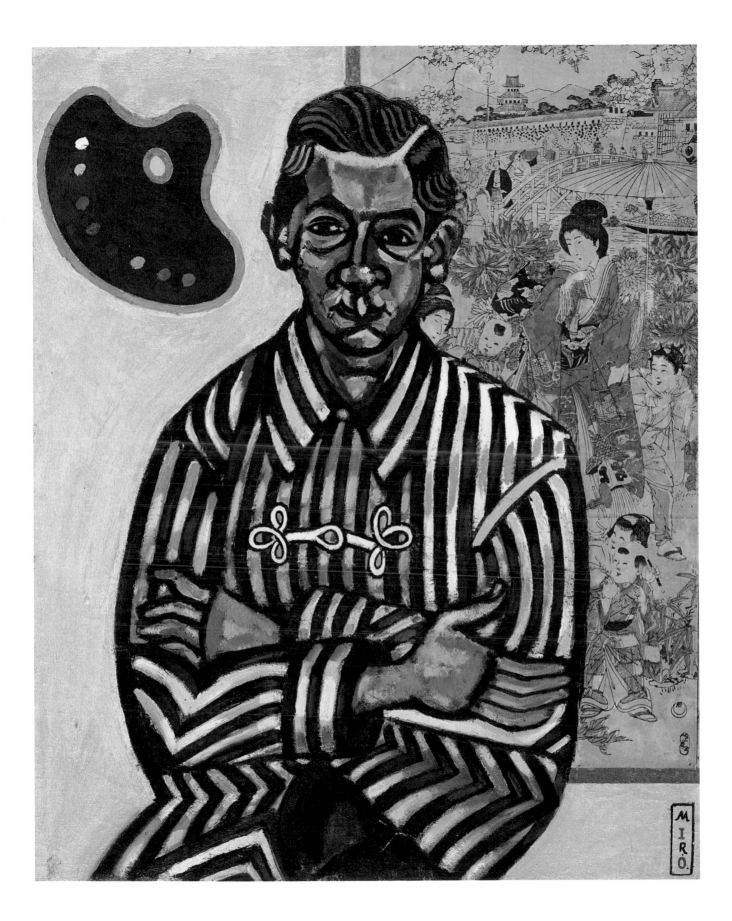

Portrait of Vincenç Nubiola, c. 1917
Oil on canvas, 104 x 113 cm (41 x 44½ in.)
Essen, Museum Folkwang

viated stint, and fulfilled his required service for three months of every year through till 1917. He spent the remaining part of the year working in a studio in Barcelona that he shared with E. C. Ricart, a friend he had got to know at the Academy Galí, and in Montroig, a village in the province of Tarragona where his family had bought a farm in 1911.

Montroig became a center of authenticity against which Miró measured the power of his art. The Catalan farmers and their families, the animals, insects, trees, rocks and soil were linked together in an animistic world that seemed to Miró to be a mirror of creation itself. Like many other artists of his generation, Miró wanted to express something eternal and essential, and he looked to his own Catalan origins for help. In so doing, Miró was following a trend toward using a kind of primitivism as inspiration in order to

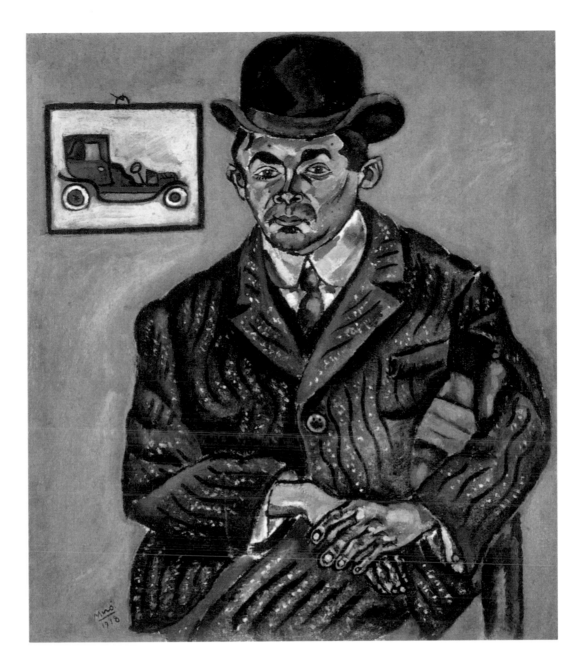

avoid traditional academic forms. Other artists had already discovered such sources as prehistoric and folk art or the art of children and the emotionally disturbed. However, Miró did not have to leave his world to find such raw and expressive qualities. Instead, he could turn inward – a natural thing for such a reserved artist.

Miró was, of course, not only a child of his middle-class parents, but also a child of turn-of-the-century Barcelona. At this time Spain had experienced a great change within its national consciousness, brought about by the country's defeat in the Spanish-American War, the destruction of its naval fleet and its loss of Cuba, Puerto Rico, the Philippines and Guam (1898). The liberal middle class had to concede that Spain was no longer a world power, moreover, it began to resent the corrupt government in Madrid, which ma-

Portrait of Heriberto Casany,
(The Chauffeur), 1918
Oil on canvas, 70.2 x 62 cm (27¾ x 24½ in.)
Fort Worth, Texas, Kimbell Art Museum

From 1917 to the beginning of 1918 Miró produced a series of portraits influenced by the Expressionists. The portraits of Nubiola and Casany show how Miró altered his technique in favor of the subject: whereas the highly rhythmized composition makes Nubiola seem restless, the chauffeur seems to rest within itself due to its self-contained form.

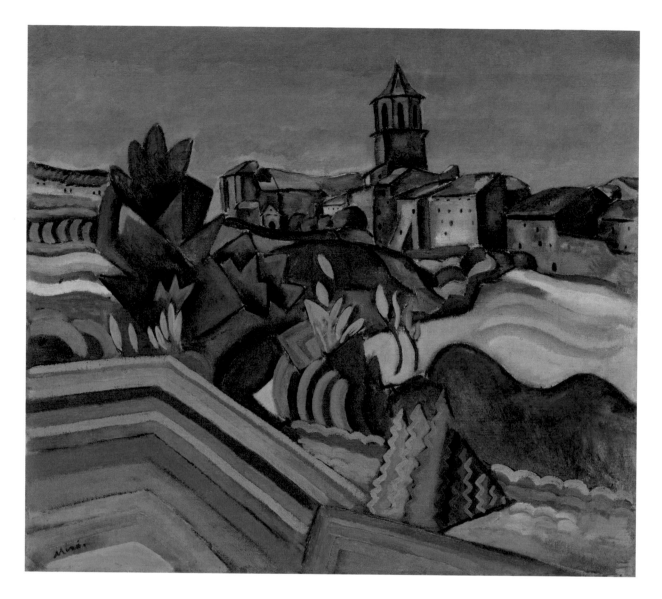

Prades, the Village, 1917
Oil on canvas, 65 x 72.6 cm (25½ x 28½ in.)
New York, The Solomon R. Guggenheim
Museum

The landscape is transformed into abstract
patterns, whose lines, however, capture the
strong impression of the natural model.

nipulated the country's progressive constitution and elections towards its own ends. This dissent began to express itself within intellectual and cultural circles in a call for renewal, for example, in the resurrection of the idea that culturally independent areas like Catalonia or the Basque provinces should become independent states. This corroborated the anarchistic desire of Spanish workers and farmers for total self-determination, free of control from Madrid. Industrialization strengthened these currents, since it had brought about a new distribution of wealth in the south, where the natural resources had attracted mines and factories. However, cultural revitalization was a controversial subject. The national identity broke down into regional identities. These, in turn, had to be rooted in tradition, yet open to the developments and spirit of the twentieth century.

Barcelona was a cosmopolitain city with an active cultural life, yet the visual arts were controlled there by official associations of painters – the powerful "Les Arts i les Artistes" group and the "Cercle Artistic de Barcelona." Miró needed to enter this community. In 1913, he joined the "Cercle

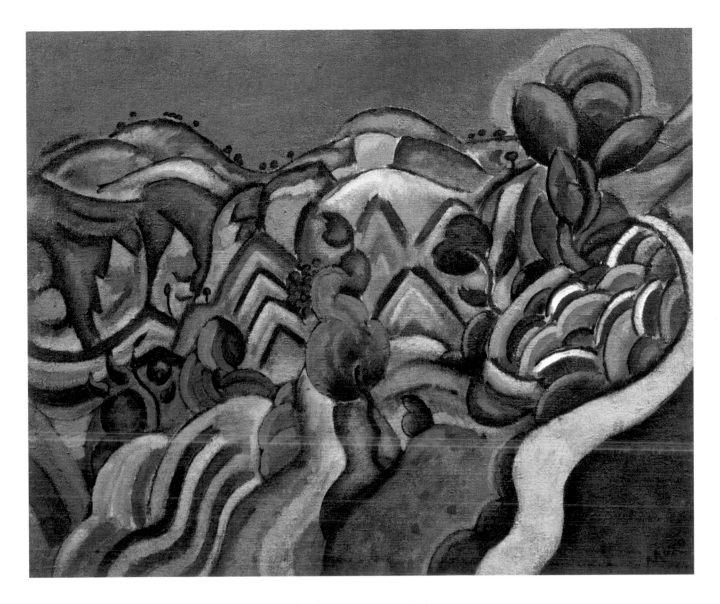

Ciurana, the Path, 1917
Oil on canvas, 60 x 73 cm (23½ x 28¾ in.)
Private collection

Miró has put aside nature's palette and has largely done away with illusionistic space. The abstract contrasts seem to show him testing out color constellations.

Artistic de Sant Lluc" for drawing classes and for the opportunity of showing his work along with that of the other members. (The Sant Lluc group was a splinter group of the "Cercle Artistic" whose tone was set by high moral principles and Christian virtue.) The spirit of cultural renewal had formulated itself in the "Noucentisme" group, a conservative movement that thought that new Catalan art should be true to its Mediterranean heritage. The Noucentists posted the tenets of harmony, structure and measure, all of which, of course, are in themselves quite relative terms refering to classicism. The Noucentists accepted avant-garde artists very selectively: Cubism, for example, was seen as an attempt to reach a new ideal form in the classical sense. At the same time, Marcel Duchamp's Futurist-inspired *Nude Descending a staircase* from 1912 was attacked for its "monstrosity" and anti-classicism.[9]

Although he deeply felt himself to be a Mediterranean artist, Miró was opposed to the selective judgement of the Noucentists. He felt that Catalan artists should remain as open as possible to impulses from abroad. Although

Poster Design for the Magazine "L'Instant," 1919
107 x 76 cm (42¼ x 30 in.)
Valencia, Institut Valencià d'Art Modern

he had never travelled beyond Catalonia – not even to Madrid – Miró became familiar with international developments in the arts. He read the poems, art criticism and articles in avant-garde Catalan and French magazines. His friends who travelled were careful to describe their impressions to him in eloquent letters. And there were also several exhibitions which offered a view of recent art, most importantly those shown by the gallerist Josep Dalmau, who had, for example, shown Cubist painters in 1912.

Miró's early work is caged in by his knowledge of contemporary art. Especially the Fauves influenced him, that group of expressive colorists who carried van Gogh's vision even further and whose most famous member was Henri Matisse. Miró used the accepted genres of still life, portrait and landscape to exercise his fledgling style. Sometimes, like in what is probably the earliest surviving oil painting by Miró, *The Farmer* (ill. p. 7), from 1912–14, the heavy brushstrokes lying clumsily next to one another tend to obscure the motif without having any saving graces of their own. The viewer can almost feel Miró struggling to coordinate the paint, his hand and his eye. A still life like *Wall Clock and Lantern* from 1915 is somewhat more successful. Here Miró emancipates some of the objects and shadows from their actual colors. Especially in the red cloth in the foreground, the paint dominates the subject of the work. The brush stroke, that is, the visible token of the painter's craft, bullies the small clock and lantern, the fruit and cloth that Miró has arranged on the table top. These objects are taken from the household and have no voice of their own. Miró is so busy painting that he is not touched by the message of the traditional Vanitas symbols he has chosen to show.

In a letter from 1916 Miró writes, "We have a splendid winter ahead. Dalmau is showing the Simultaneists: Laurencin (…), Gleizes, who wrote the book on Cubism together with Metzinger. The classic Impressionists and the modern 'Fauves' will be at the French exhibition."[10] This French exhibition that Miró was so looking forward to was a major art event in Barcelona. It was a substitute for the large annual show of the important French painting societies, which, because of the First World War, could not take place in Paris. The catalogue had 1462 entries. Miró was not disappointed. It was his first face-to-face meeting with paintings by Renoir, Bonnard, Matisse, Monet, and Redon, among others. The war had swept some French artists and intellectuals over to neutral Spain as well. In Barcelona they often collected in Josep Dalmau's gallery, where, for example, in 1917 Miró met the Cuban Dadaist Francis Picabia, who had come to Barcelona to publish several issues of his influential avant-garde magazine *391*.

In general, Catalan sentiment was pro-France during the war, which deflected not only artists, but also wealth to Spain. Miró, who did not enjoy being a soldier, could become quite virulent when speaking of the Germans: "These days of the successful allied offensive are for us Francophiles the greatest joy. We will see if they can throw out this uncouth mob once and for all, and then we will all go to Paris and surrender ourselves to France's delights, which we can see in their most expressive form in Renoir's painting (his *Moulin de la Galette,* his women, his nudes!)."[11] A negative attitude

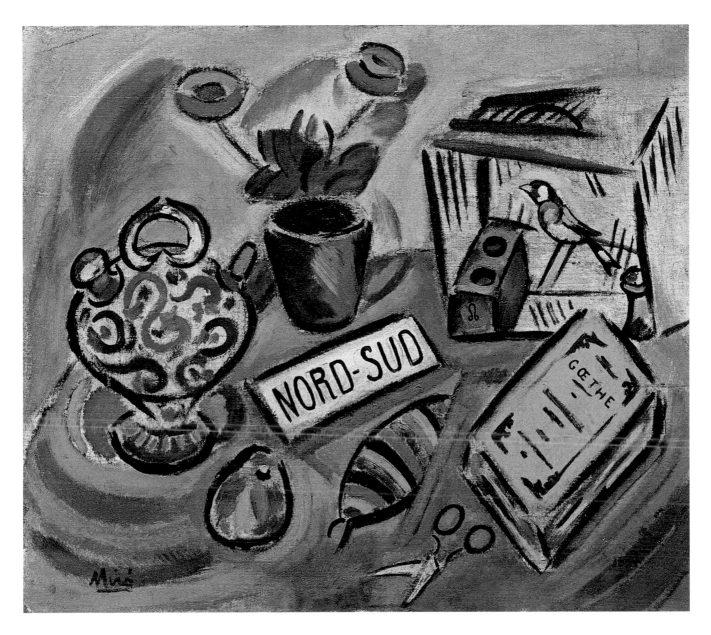

North-South, 1917
Oil on canvas, 62 x 70 cm (24½ x 27½ in.)
Saint-Paul de Vence, Adrien Maeght Collection

This still life reveals something of the cultural
influences on Miró. There are references to folk
art and literature as well as to the French avant-
garde, represented by the magazine *Nord-Sud*
which pioneered Dada and Surrealism.

towards Germany and its culture was considered to be almost an open dec-
laration of leftist intellectual sympathies during this period.[12] Around this
time, Miró dared to show some of his work to the gallerist Dalmau, who
promised him a solo exhibition in the gallery at the beginning of 1918. With
this opportunity in his mind, Miró began to paint more canvases than he
had ever painted before. The Fauves were still inspiring him. Not that Miró
wanted to emulate French painting, or any existing work for that matter.
Theoretically he considered all past styles, however recent, to be sand traps.
How might one then explain Miró's dependence on modern French painting
at this point? It was probably a form of rebellion. Despite loyalties to his
homeland, Miró had difficulty accepting all of the conservative Catalan art-
ists' demands, who seemed to be looking for a defined Catalan style as a flag
around which to gather. He was young, but already quite sure of what he
thought about modern developments in painting and he was not about to

soften on his stance. Miró was too much of an individualist to simply subscribe to an aesthetic party platform of Mediterranean art, which wanted to move forward, but only at a safe trot. In a letter from 1917 to his friend and studio-mate Ricart, the twenty-four-year-old Miró wrote, "Here, in Barcelona, we lack courage. When the critics who are most interested in the modern and ultramodern movements find themselves in front of an outmoded academic, they melt and end up speaking well of him."[13]

Miró resolved to be uncompromising. His first one-man show at Dalmau's gallery ran for three weeks from January to February of 1918 and contained sixty-four canvases and many drawings dating from 1914 to 1917. Some of the work was damaged in the violent reaction to the images. Perhaps the *Portrait of E. C. Ricart* (ill. p. 11) from 1917 was among the paintings exhibited. It incorporated a Japanese print in the background with the glaring colors of the Fauves. The bold abstract patterning of Ricart's clothing almost crushes the delicate, flowing lines of the image behind him. His face is cartoon-like, but also suggestive of romanesque portraits in its frontality and linear stylization.

In a picture like *Ciurana, the Path* (ill. p. 15), 1917, painted in the hilly landscape near Montroig, Miró has put aside nature's palette. The individual brushstrokes have integrated themselves into a rhythm of bright, broken colors that dip and rise in groupings of flat, striped patterning. Miró has almost done away with illusionistic space here. He seems to be testing out

The Waggon Tracks, 1918
Oil on canvas, 75 x 75 cm (29½ x 29½ in.)
Private collection

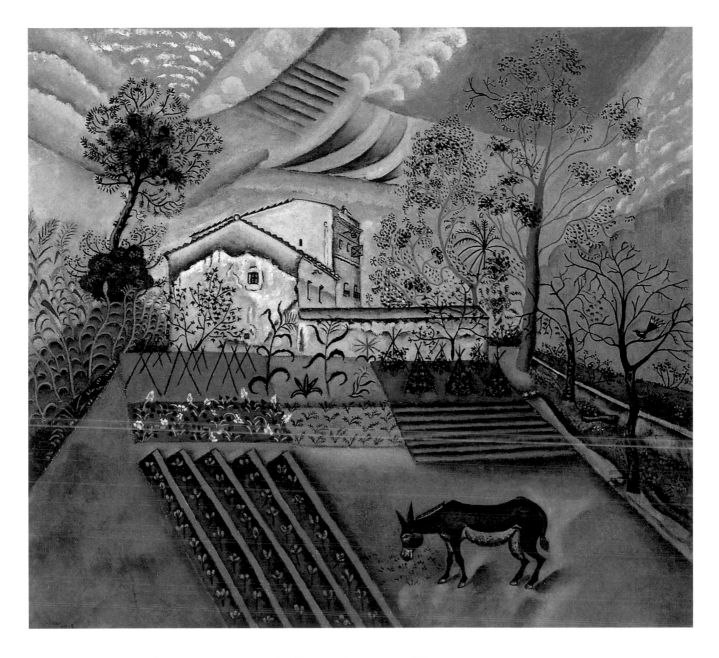

color theories in his abstract contrasting of yellows and greens and blues
and purples. Another work from 1917, *North-South* (ill. p. 17), a still life,
reveals a bit of Miró's cultural and inspirational background. Arranged in a
centrifuge of color (a table top), there are hints of different cultural artifacts,
including literature (maybe Goethe's color theory). In the middle of the
table lies the French poet Pierre Reverdy's brand new magazine *Nord-Sud*,
which was named after the Paris metro line connecting Montmartre with
Montparnasse. *Nord-Sud* began its publication with a bow to Guillaume
Apollinaire, the experimental, amusing and brilliant poet, critic and intel
lectual whom Miró read. With Tristan Tzara and André Breton as authors,
the magazine opened the road to Dada and Surrealism. Though far away in
Spain, which in 1917 was going through a violent political crisis, Miró had
his finger on the pulse of an era.

The Vegetable Garden with Donkey, 1918
Oil on canvas, 64 x 70 cm (25¼ x 27½ in.)
Stockholm, Moderna Museet

Like *The Waggon Tracks* this picture is rich
in detail, reflecting Miró's treasuring of small
things, of the "unimportant."

Man Ray
Portrait of Joan Miró, c. 1930

This portrait by Man Ray plays upon an event that took place in a studio in Paris: when Miró refused to make any comment during a debate, his neighbor Max Ernst grabbed a coil of rope, placed a noose around his neck and threatened him with the death sentence should he give no answer. Miró remained silent.

"I have turned inwards into myself, and the more sceptical I became about my surroundings, the closer I came to those places where the spirits live: the trees, the mountains, friendship."

— JOAN MIRÓ

PAGE 21
Self-Portrait, 1919
Oil on canvas, 75 x 60 cm (29½ x 23½ in.)
Paris, Musée Picasso

This self-portrait was painted during Miró's first years in Paris. The folds and swells of his face appear chiselled, the gaze of the young man is fixed calmly on the observer. The portrait does not as much reveal as signalize his determination to go his own way as an artist in Paris.

Later in 1918, Miró and some of his like-minded friends finally ended up forming their own group within the Sant Lluc group which they named after the painter Gustave Courbet, whom they admired for his radicality. The "Courbet" group (Miró, E.C. Ricart, Josep F. Ràfols, Francesc Domingo and Rafael Sala, later joined by Llorens Artigas) considered itself the progressive subset of the artists in Barcelona. It planned to "step over all the rotting bodies and fossils"[14] of the local art world and leave them behind. They exhibited in the rooms of the "Cercle Artistic de Sant Lluc." Their paintings were strident and colorful, definitely not the new classicism expected by dominant conservative artists. The Courbet group was not looking for approval and it did not get much. The predictable tone of rejection is reflected in the comment of one fellow painter who visited the first exhibition and exclaimed, "If this is painting, then I am Velázquez!"[15] From July to early December of 1918, Miró remained in Montroig. He must have been thinking about his first exhibitions and about the art world in Barcelona. Some of the harsh criticism might have struck him as partly true; at any rate, another stage of development began. Ràfols, a fellow member of the Courbet group who later wrote about Miró, called it his "detailistic phase." Jacques Dupin, Miró's biographer, called it "poetic realism." In July of 1918 Miró writes to Ricart, "I started working only a few days ago. – I have been at Montroig since the beginning of the month; the first week I was here I didn't want to think about dirtying a canvas or about anything at all. – In the morning to the beach to lie belly up and (…) in the afternoon an excursion or bicycling for kilometres. The second week I began thinking about working and in the middle of last week I started two landscapes. No simplifications or abstractions, my friend. Right now what interests me most is the calligraphy of a tree or a rooftop, leaf by leaf, twig by twig, blade of grass by blade of grass, tile by tile. This does not mean that these landscapes will not finally end up being Cubist or wildly synthetic. But we shall see (…) Next winter the gentlemen critics will continue to say that I persist in my disorientation."[16]

Miró was painting outside and meditating while doing it. He must have been reading the American poet Walt Whitman, particularly the "Song of Myself": "I loaf and invite my soul, I lean and loaf at my ease observing a spear of summer grass." In the country, he seemed less concerned with the issue of painting style than in trying to show his beloved Montroig. He painted four landscapes from around the farm: *The Vegetable Garden with Donkey* (ill. p. 19), *The Brick Factory, The House with the Palm Tree* and *The Waggon Tracks* (ill. p. 18). The landscapes share a naive treatment of details, combining the way things are counted out and included in Gothic retables with delicate decorative patterning. His colors have changed, become more natural and earthen. Just a month later he wrote to J. F. Ràfols, "This week I hope to finish two landscapes (…) As you see, I work very slowly. As I work on a canvas I fall in love with it, love that is born of slow understanding. Slow understanding of the nuances – concentrated – which the sun gives. Joy at learning to understand a tiny blade of grass in a landscape. Why belittle it? – A blade of grass is as enchanting as a tree or a mountain. – Apart

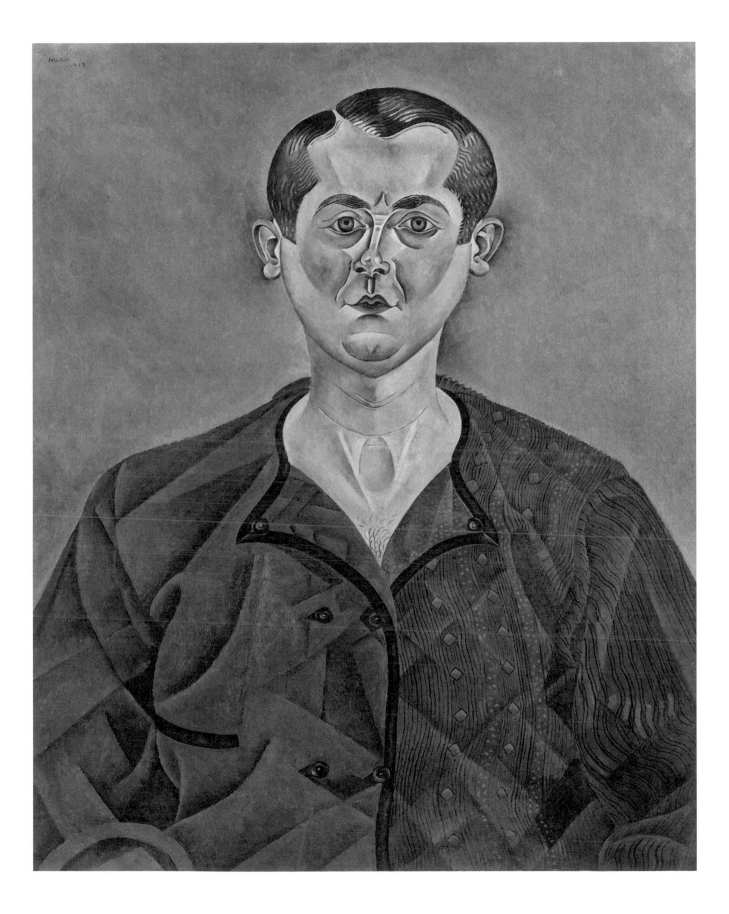

from the primitives and the Japanese, almost everyone overlooks this which is so divine. – Everyone looks for and paints only the huge masses of trees, of mountains, without hearing the music of blades of grass and little flowers and without paying attention to the tiny pebbles of a ravine – enchanting. I feel the need for great discipline more everyday – the only way to arrive at classicism – (that is what we should strive for – classicism in everything). I consider those who are not strong enough to work from nature to be sick spirits and I refuse to believe in them."[17]

In 1919 Miró painted a puzzling image: a *Self-Portrait* (ill. p. 21) in which he is wearing the same collarless red shirt that Vicente Nubiola has on in Miró's portrait of him (ill. p. 12). On Miró it looks like silk pyjamas. It flaps open at the throat, exposing a sensual expanse of neck and a small, yet vital angle of chest hairs. Somehow, he appears almost undressed. In comparison with the loud *Portrait of E. C. Ricart* (ill. p. 11) two years earlier, Miró has captured a soft, hushed atmosphere here. The dimples, folds and swells of his young face appear chiselled, his hair impeccably trimmed and combed into the semblance of an oiled cap. Perhaps the most interesting aspect of the painting is the similarity between the shirt's treatment and the detailistic patterned landscapes. Miró seems to need to build an abstracting foundation from which the individual – here a face and in the landscapes a building, a donkey or a farmer – may rise. While one side of the pyjama probably shows its original pattern, the other side has been allowed to flower into a Cubist-inspired balance of triangular depths and folds. As a shirt Miró has put on, it functions as a kind of symbol of the way he used the appearance of Cubistic style, namely as a contemporary cliché clothing the thing he chooses to paint. Never do these angular forms really seem to have grown out of the structure of the entire image, or to be at one with it. Miró did not execute many portraits, and this is, apart from a further self-portrait from 1917 (ill. p. 6), the only painting of him as a young man. It shows the Miró who arrived in Paris in 1920, twenty-seven years old and determined to grow beyond existing schools of Parisian painting. Maybe that is what Picasso thought, too, when he bought the picture that year after meeting Miró for the first time.

A strong contrast between supporting base and things shown is demonstrated by *The Table (Still Life with Rabbit)* of 1920 (ill. p. 23). While the table and the space around it has been broken down into stylized angular shapes, the rabbit, fish, vegetables, grape leaves and chicken are quite realistically painted. Of the objects on the table, only the inanimate wine jug has been conquered by style. Strangely enough, the animals look alive still, although they are probably meant to be food.

The Table (Still Life with Rabbit), 1920
Oil on canvas, 130 x 110 cm (51¼ x 43¼ in.)
Private collection

On the table ornamented in Cubist style lie naturalistically presented animals and objects. Unlike the Cubists, Miró does not incorporate the realistic elements into the geometrical structure of the picture. Thus the unbridgeable gap between the two worlds remains.

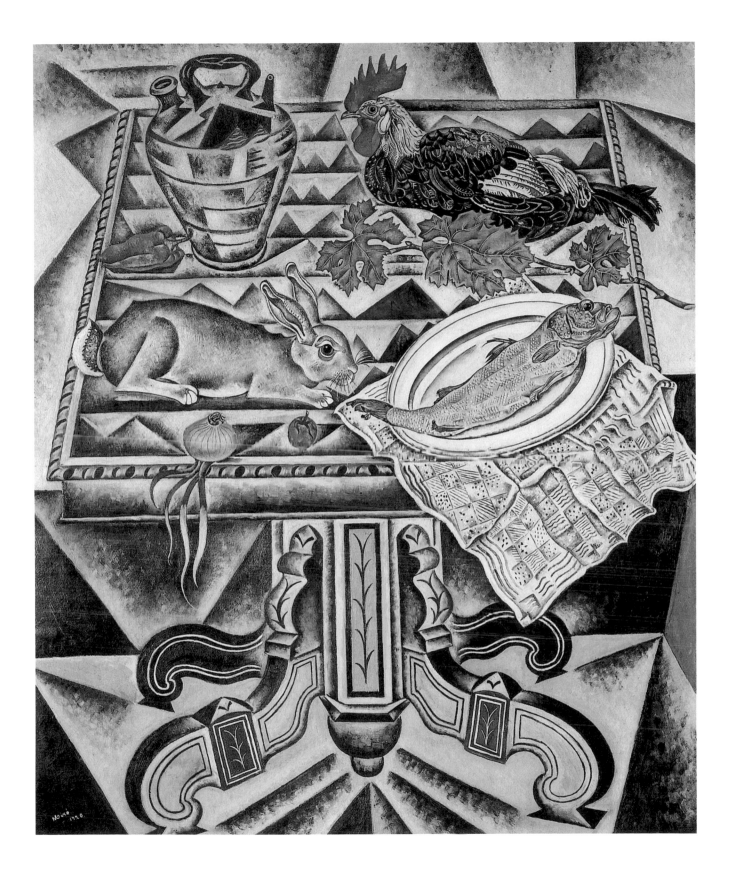

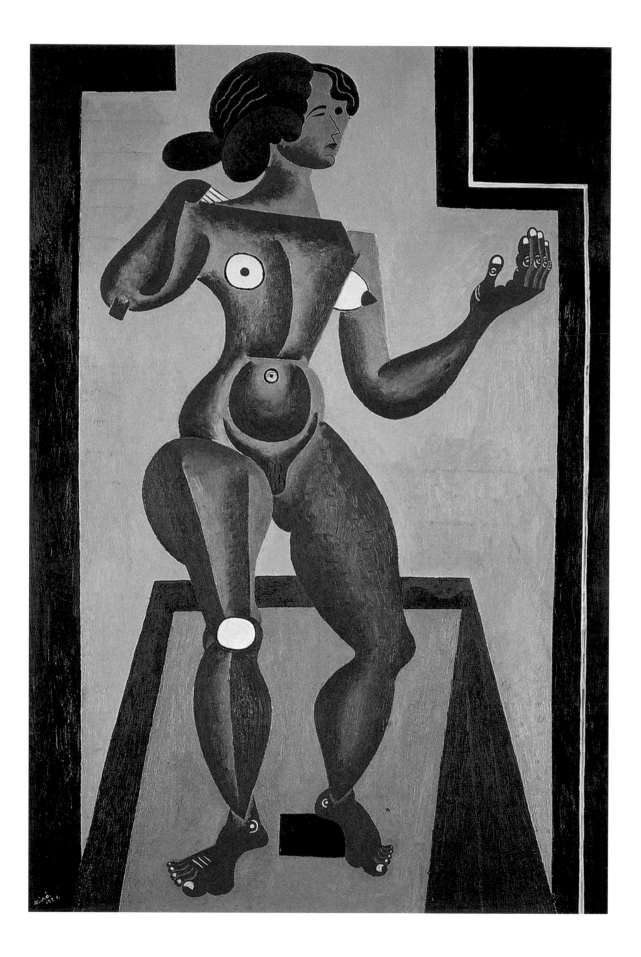

A Monk, a Soldier and a Poet

Miró arrived in Paris in 1920 after considerable preparation and careful consideration of just how he could finance his stay there. He wrote in one of his letters, "I, who currently have NOTHING, must earn my living whether it be here or in Paris or in Tokyo or in India", but he seems to have received a paltry sum from his mother to cover most expenses.[18] He lived in a hotel; Miró did not have a studio, which didn't matter since he was not able to paint. The city had simply overwhelmed him.

While he was in Paris, he met with Picasso, whose mother he had already visited in Barcelona to see her son's pictures there. Picasso was friendly towards him and supplied him with some introductions. "In the beginning Picasso – naturally-reserved with me – lately now, after having seen my work, very effusive; hours of conversation in his studio, very frequently."[19] Dalmau arrived in Paris as well, and began making contacts for Miró. He actually managed to place some of Miró's paintings in private collections and showed his work to influential people. Just about the same time Tristan Tzara came to Paris and started off Dada events in spring of 1920. Miró, who already knew several of the artists associated with Dada from Barcelona, kept up with these developments, even attending a Dada festival. Dada's poetic anarchy impressed Miró. Thus his experiences in Paris stimulated him in highly contradictory ways. At the same time that he was visiting the Louvre, that heaping treasure chest of art, Miró also exposed himself to a nihilistic group that propagated art's destruction as an institution. Miró wrote in 1920, "I much prefer the nonsense of Picabia or any one of the silly Dadaists to the easygoing ways of my compatriots in Paris, stealing from Renoir (whose only value now is as a classic) or producing a watered-down mixture of Sunyer and Matisse."[20] Miró seems to be echoing in his own way the message of Picabia's jokey work of 1920 in which he mounted a stuffed, dislocated monkey on a cardboard background and wrote in his own handwriting around the edges of the cardboard that it was a portrait of Cézanne, Rembrandt and Renoir.

After the initial wave of awe, Miró was able to recover his balance and observe the Paris art world with a critical eye. He recognized that a lot of con-

Standing Nude, 1917
Pencil on paper, 21.2 x 15.1 cm (8¼ x 6 in.)
Barcelona, Fundació Joan Miró

PAGE 24
Standing Nude, 1921
Oil on canvas, 130 x 96 cm (51¼ x 37¾ in.)
Private collection

Miró increasingly makes use of basic geometric forms: fauvistic or cubistic leanings practically disappear, and the composition assumes greater importance. On one level, the picture shows a woman but it also shows a fitting together of working parts.

temporary painting was being done for sale and not as the necessary expression of some imminent idea. The idealist and moralist Miró, who had little money himself, became somewhat disgusted. In a letter that reveals his own high expectations of himself, as well as his religious reference point, he writes, "I have seen exhibitions of the moderns. The French are asleep. Rosenberg Exhibition. Works by Picasso and Charlot. Picasso very fine, very sensitive, a great painter. The visit to his studio made my spirits sink. Everything is done for his dealer, for the money. A visit to Picasso is like visiting a ballerina with a number of lovers (…) In other places I saw paintings by Marquet and Matisse; there are some that are very lovely, but they do a lot just for the sake of doing them, only for dealers and the money. In the galleries you see a lot of senseless junk (…) The new Catalan painting is infinitely superior to the French; I have absolute confidence that Catalan Art will be our saviour. When will Catalonia allow her pure artists to earn enough to eat and paint? Catalonia's rough way of treating spiritual things might be the Calvary of redemption. – The French (and Picasso) are doomed because they have an easy road and they paint to sell."[21] In July of 1920 he was back on the farm in Montroig, and began to work inspired by the jolts he had received in Paris. Still, it was the second trip to Paris that actually brought about a change in his work. In 1921 he managed to take over a Paris studio from the Spanish sculptor Pablo Gargallo, who taught in Barcelona during the winter months. The studio was in the Rue Blomet, and as fate would have it, it was right next door to where the artist André Masson had just rented a place for himself.

Miró's years spent in the Rue Blomet are treated by most historians as an heroic phase of his artistic career. Miró himself calls it "a decisive place, a decisive moment for me."[22] In his "Memories of the Rue Blomet," transcribed by Jacques Dupin, he gives a vivid picture of the time he spent there from 1921 to 1927. As Miró wrote, "More than anything else, the Rue Blomet was friendship, an exalted exchange and discovery of ideas among a marvellous group of friends."[23] The list of writers and artists that Miró got to know during these years reads like an intellectual history of the period, for example, Max Jacob, Michel Leiris, Roland Tual, Benjamin Péret, Pierre Reverdy, Paul Éluard, André Breton, Georges Limbour, Armand Salacrou, Antonin Artaud, Tristan Tzara, and Robert Desnos, but also Henry Miller, Ezra Pound, and Ernest Hemingway. Particularly the poets of this group influenced Miró. They tried to get rid of structure and worn out imagery in exchange for immediate and brilliant sensory impressions. Often, their poetry was highly visual and object-oriented. Miró, who was reserved and kept to a rigorous work schedule with a soldier-like discipline, was drawn into this world through his proximity to the more gregarious André Masson. Masson could work with all kinds of visitors and activity around him, while Miró needed absolute solitude and quiet.

In April of 1921, Miró had his first exhibition in Paris. It was at the gallery Licorne, which was known for its avant-garde shows. Not a single picture sold. Even for a man like Miró with a martyr-like attitude towards becoming an artist, this must have been a disappointment. In 1928, however, he was able to say, "that show wasn't talked about very much, but the few people who did

Standing Nude, 1918
Oil on canvas, 152.4 x 120.3 cm (60 x 47¼ in.)
Saint Louis Art Museum,
Purchase: Friends Fund

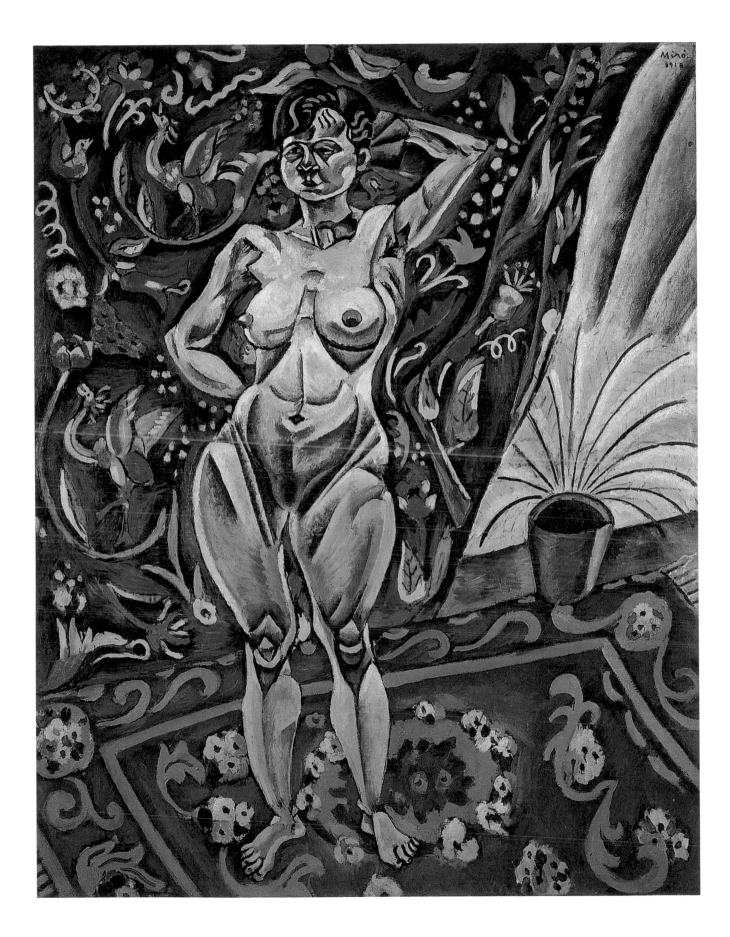

Sitting Nude, 1917
Pencil on paper, 31.3 x 21.5 cm (12¼ x 8½ in.)
Private collection

PAGE 29
Nude with Mirror, 1919
Oil on canvas, 113 x 102 cm (44½ x 40¼ in.)
Düsseldorf, Kunstsammlung Nordrhein-
Westfalen

Whereas the embroidery on the stool appears
almost tangible, the square formality of the
woman removes her from the observer: her body
appears as a protective armor, her face expressive
of a mysterious, inwardly directed calm.

talk about it had high hopes for me and were sure I'd end up being accepted."²⁴
When he returned to Montroig in the summer, he made a serious attempt to
eliminate stylistic clichés from his work; fauvistic and cubistic leanings prac-
tically disappeared. However, a new influence makes itself felt – that of an art
using basic geometric forms. Shortly before and during the First World War,
Marcel Duchamp and Francis Picabia had begun making images that showed
fantastic "machines" with cogs, gears, pipes, screws and other undefined ab-
stract parts. Often these machine parts had an anatomical, particularly a sex-
ual intent. They were highly inventive, yet at the same time they illustrated
the trend toward using abstract geometric forms that was spreading through-
out Europe as Constructivism, De Stijl and Bauhaus. Miró followed the trend
under Picabia's protection, thus keeping himself at a distance from the more
political aspects of this development in form, which, in general, was associ-
ated with social reform. In a painting like *Standing Nude* from 1921 (ill. p. 24),
Miró has placed the female figure upon a construct of parallelogram and
rhombus, with her left foot resting upon a black rectangle. Behind her is a
field of squared off blue, that has been set off by squared off bars of black –
one of them interrupted by a white line that retraces its angular shape. Her
breasts appear piercing and hard, like bullets. At the same time, her frozen
gesture and the delineation of her anatomy has a Romanesque quality, such
as in the circular knee cap and the partitioning of her body. Instead of the
repetitive beating of pattern encountered in his landscapes, Miró sets out
here to create a counter-point rhythm. The zigzagging movement from the
black block under the model's foot, to her white knee cap, pubic hairs, the
white breasts and fingernails and the model's black hair pull the viewer's
eyes back and forth up the canvas. The white border line to the right lights
up the side of the canvas to which the model is looking. The black square
area facing her echoes the square beneath her foot. All in all, the composi-
tion, which is relatively empty and flat, appears highly constructed. On one
level, the picture shows a woman, but it also shows a fitting together of
working parts. Here Miró demonstrates a repeated use of abstract geometric
shapes that actively point toward the balance of forms. From now on, balance
was to become a presence, not only a compositional element in Miró's work.

Miró's most famous painting and a so-called "key" to his work, *The Farm*
(ill. p. 31) was also begun in 1921. It, too, contains numerous abstract elements
and correspondences that would be hard to explain without the new influ-
ence, for example, the black circle and the white base of the eucalyptus tree in
the middle of the painting, the red square to its right defying the depth of the
chicken coop it describes, the red tiles and rhomboid section of black to the
lower left, and even the round moon (could the sun be that pale?), the red
wagon wheel and the rooster's perch. The lyric softness and organic forms of
Miró's previous landscapes are gone. He has chosen to show many metal and
wooden objects, which do not overlap each other and stand out in their hard-
edged entirety against the background. The hard thorniness of the standing
nude woman (ill. p. 27) is echoed here in the spiny trunk of the nearly leafless
eucalyptus tree and the stony, dry, red-brown earth.

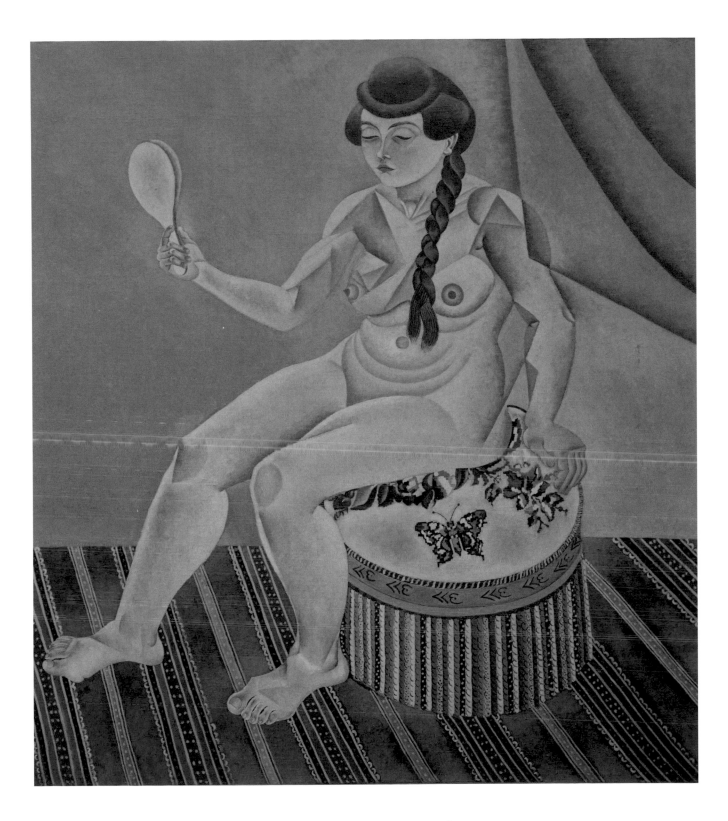

In *The Farm,* Miró uses some aspects of Romanesque style. For example, the size of various details does not accord with nature and perspective, but rather with Miró's feeling about their importance. He writes, "I don't think it makes sense to give more importance to a mountain than an ant (but landscape artists just can't see that)."[25]

While the Romanesque artist was constructing the hierarchy of animals and people in his compositions, he was acutely aware that he must control their isolated strength by binding them tightly into the composition through a tension of balance and symmetry. It was a highly conscious form of art comparable to architecture, not so much interested in telling a story or showing reality than in erecting a conceptual framework for a Christian mind-set.

Miró was having a difficult time melding contemporary and traditional factors, particularly since he wanted to avoid style. "During the nine months I worked on *The Farm* I was working seven or eight hours a day. I suffered terribly, horribly, like a condemned man. I wiped out a lot and I started getting rid of all those foreign influences and getting in touch with Catalonia."[26]

In the main axis of *The Farm*, the story appears to be one of fertility – possibly as a metaphor of artistic productivity – with related details strewn about the surface of the painting like upon a medieval tapestry. It is intriguing to "read" the repetitive references. Right in the foreground Miró has placed a red-spouted watering can for whom a bucket has tipped its skirt. Behind it is a French newspaper whose name *L'Intransigeant* (The Uncompromising) is truncated by a fold so that only the syllable meaning "into" or "within" remains. Referring as it does to the watering can under which it has been placed, it seems to be a written instruction to the male moistener. If we follow the tiles and small path to the back, we see seven imprints of bare feet that stop suddenly without having got any further. The path, however, continues along to a square well or water trough. A woman is leaning over it and there are a few pots, a bucket and a bottle near her. Behind her, and positioned almost in the middle of the painting like its perspective point, is a squatting, idol-like figure, hairless and naked, foetal and frog-like. Is it her child? Is the dog barking at it or at the moon, like on a later painting of Miró (cf. ill. p. 47)? Behind the well is a pump or mill that is powered by a mule harnessed into a circular tract, going around and around and not getting anywhere, but still accomplishing something. The rooster, the rabbits and the goat add sexual aspects, but they are also details of life on the farm at Montroig. The vegetation is sparse; either the crops are somewhere else or the farm, unkempt as it appears, is no longer in working order. On the lower left a huge wild plant erupts into bloom. It may well be the large type of algarve cactus that flowers only once every seven years in a cycle of slow but dramatic fertility. Considering Miró's struggling development, these details might hint that he finally felt himself approaching the right source.

The Farm is dominated by the light, framing buildings of chicken coop and stall, and the eucalyptus tree in the center. In one sense it is a highly architectural painting, because it is so carefully constructed. Miró reworked the painting many times, bringing it with him to Barcelona and Paris. He always stressed the difficulty of completing it. As he told in an interview late in his life, expanding the time he worked on it, "It took me practically two years to finish it, but not because I had any trouble actually painting it. No, the reason it took so long was that what I saw underwent a metamorphosis. The painting was absolutely realistic. I didn't invent anything. I only eliminated the

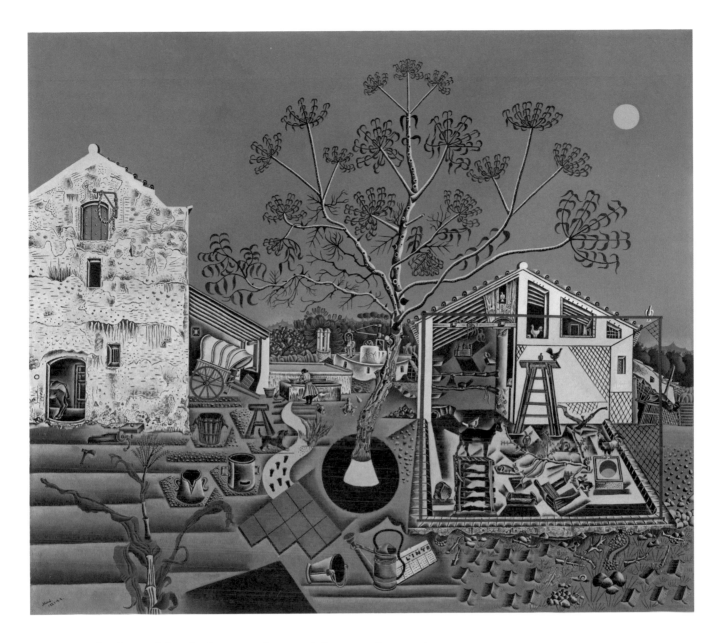

The Farm, 1921/22
Oil on canvas, 132 x 147 cm (52 x 58 in.)
Washington, D.C., National Gallery of Art,
Gift of Mary Hemingway

A key work of Joan Miró, this picture is open
to numerous interpretations. The author Ernest
Hemingway bought the picture because he saw
his impressions of the Catalan landscape and
mentality reflected in it.

fencing on the front of the chicken coop because it kept you from seeing
the animals. Before this metamorphosis occurred I had to capture even the
smallest detail of that farm I had right there before my eyes in Montroig. For
instance, I very carefully copied that big eucalyptus tree in the center of the
canvas. Every time I strayed from the model, I'd take one of those pieces of
blackboard chalk that schoolchildren use and I'd chalk over what I'd done and
make the necessary corrections. I was (…) convinced that I was working on
something very important, attempting to summarize the world around me."[27]

The tree, with its deep roots and potential for growth, were a literary sym-
bol of the Catalan people,[28] which may be why Miró put a eucalyptus in the
center of the farm. The Barcelona architect Antoni Gaudí, a fellow Catalan
much admired by Miró, also once explained the tree as his inspirational
source. Gaudí, who died in 1926 after being hit by a streetcar, once pointed to
the eucalyptus tree outside his window and said, "An upright tree; it carries

its branches and these carry the twigs, which in turn carry the leaves. And every single part grows harmoniously, magnificent, since the artist God himself has made it. This tree doesn't need any exterior help. All parts are balanced in themselves."[29] Although Gaudí and Miró refer to two different eucalyptus trees, they are both metaphoric images of a natural and national correctness of expression and functionality. Usually a comparison is made between the undulating lines of Miró's later work and the curving lines of Gaudí's architecture, thus marking the Art Nouveau origins of Miró's line. There might, however, be parallels to be found in less obvious ways, such as in the methods of working and in both men's dedication to re-inventing Catalan art within both Catalan tradition and the context of the twentieth century. Gaudí, for example erected most of his main works in brick or stone instead of using more modern materials. Yet he was mainly concerned with the functional form as it grew from structure. Gaudí's unconventional archi-

Still Life – Glove and Newspaper, 1921
Oil on canvas, 116.8 x 89.5 cm (46 x 35¼ in.)
New York, The Museum of Modern Art,
Gift of Armand G. Erpf

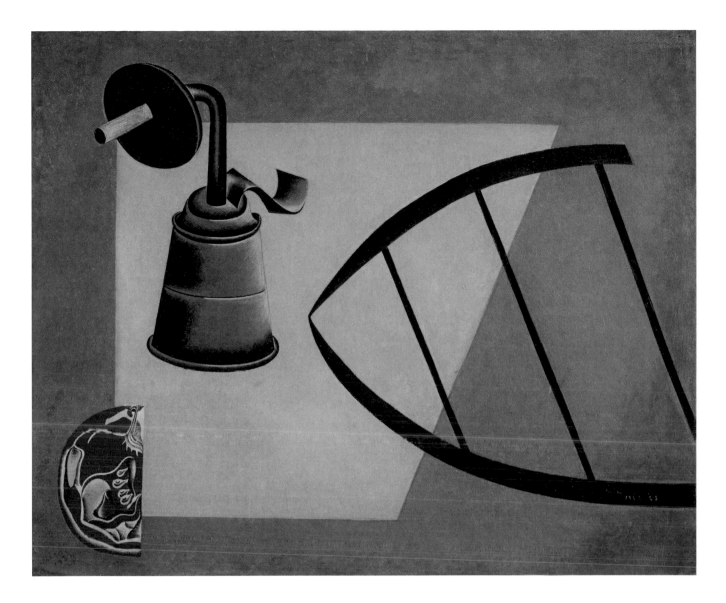

tectural solutions to the problem of dealing with weights and supports may have directly influenced Miró. There is at least one more strain of contemporary influence hovering within *The Farm*, that is, that of the naive. By 1921 when Miró painted his key work, naive painting had been recognized by the avant-garde art world as a genre in its own right. Henri Rousseau had established a labored realism that inadvertently underbid conventional expectations of art and appeared humorous, enigmatic or dispossessed. Rousseau, the home-grown primitive, was loved and feted by the avantgarde; his work was wrong at the right time. Just as Rousseau placed his figures into a set-like situation, similar to the way a child would place a doll into a doll house, so, too, did Miró lift and place the objects into his composition. While Rousseau created a frozen stillness within his images, Miró managed to breathe life to the things he showed in *The Farm*. In this way Miró, who spent much of his childhood in the Catalan countryside, was perhaps more truly child-like than Rousseau. As anyone knows who has experienced very small children, nothing, not even a two-dimensional image, is inanimate to them. Miró never

The Carbide Lamp, 1922/23
Oil on canvas, 38.1 x 45.7 cm (15 x 18 in.)
New York, The Museum of Modern Art

In this picture Miró drastically reduces the objects to clearly delineated forms arranged against a flat background. While the lamp is slightly shaded, the grid is composed of lines only.

PAGE 35
The Farmer's Wife, 1922–23
Oil on canvas, 81 x 65 cm (32 x 25½ in.)
Paris, Musée national d'art moderne,
Centre Georges Pompidou

Miró explains the circle next to the cat as an afterthought: "I found that during the first stages of painting the farmer's wife I had made the cat too big and this disrupted the picture's balance. That is the reason for the double circles and the two angular lines in the foreground. They look symbolic, esoteric; yet they have no fantasy character."

fully explained the meaning of *The Farm,* but insisted that it was merely Montroig for him. (He did, however admit to altering the wall of the stable by adding moss and cracks so that the patterned surface look more in balance with the chicken coop wire.)[30] After it was rejected by many galleries, Hemingway bought the picture. He had to scrape the money together to do so, and later he gave the painting to his wife, who lent it to the National Gallery of Art in Washington, D.C. Hemingway repeats Miró's claim that he painted it in nine months,[31] "as much time it takes for a woman to make a baby" – a statement that intuitively picks up on the intimations of fertility and gestation in the painting. Miró's relationship to the farm was, however familiar, still that of an urban bourgeois visitor who preserved his mental distance from real farm life. As late as 1930, over 49 per cent of the working population in Spain were still farmers. During the Second World War, even more people worked the land from necessity. At that point, Miró himself would also consider the farm in Montroig as a possible source of income. In his Catalan notebooks of 1940/41 he writes about trying to reorganize his life to become financially independent, "and never let myself go so far as to become a businessman (…) must go into the matter of the farmhouse seriously, it would afford me an independent livelihood and, what's more, this direct contact with the soil and the men who till it and the elements involved in it would be of great human value to me, they would enrich me as a man and as an artist."[32] In a way, Miró was a true Romantic, using the authenticity of the farmers and landscape as a raw material that he focused on. Perhaps he succeeded in capturing the essence of the farm for himself, while at the same time giving expression to all of the art world impulses weighing on his mind.

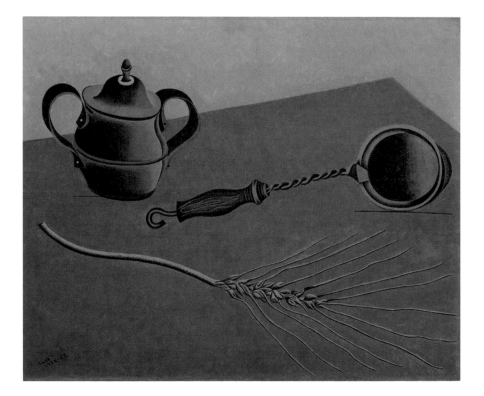

The Ear of Corn, 1922/23
Oil on canvas, 37.8 x 46 cm (15 x 18 in.)
New York, The Museum of Modern Art

Like *The Carbide Lamp, The Ear of Corn* is a very reduced picture. It reflects Miró's formal interset in linear shapes as demonstrated in the grains.

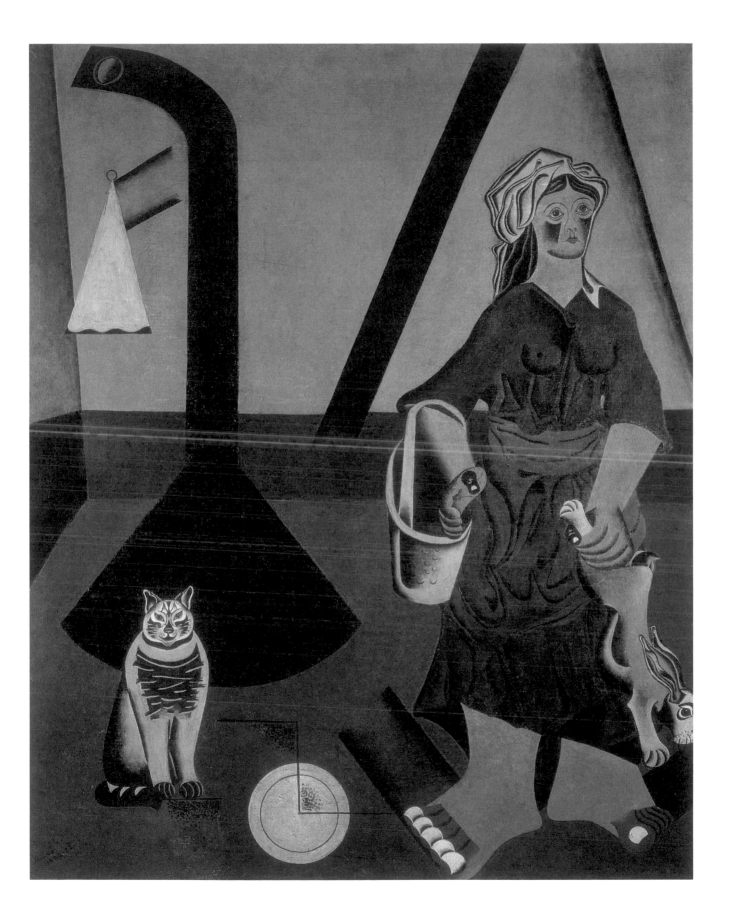

Poetic License

A change had been building up in Miró's work. From 1923 he began to invent a new cosmos of beings and symbols. In *The Tilled Field* (ill. p. 38) it is possible to still identify the farm at Montroig. Yet, the animals, house, fields and plants have become disquieting presences, stretched, swollen and barbed sometimes even into ugliness. At the same time, they insist on their identities. Miró appears to be giving an anti-cerebral, pro-sensual message in the painting. A large lizard with a dunce cap becomes a jack-in-the-box that pops out of a pipe in a startling greeting. The fish, only head, has lost its body. The ear is a giant listener. The eye in the crown of the tree sees all. Barbs invite and dispel touch. Miró is showing how he loves his Catalan homeland with his body and its senses, yet the landscape seems ultimately to resist him. It awakens his reverence, but it is not paradise. The flags waving on the gnarled tree – Catalan, Spanish and French – tip up in optimistic crescents. Birds wheel in the sky next to a cactus tree's triangular crown. Freedom? The folded newspaper in the foreground says "Day" to us in French, but a little night is falling diagonally onto the upper right corner of the painting, where something is hanging – a large spider or perhaps only a leaf.

In its startling juxtaposition of figures, *The Tilled Field* owes something to the collage; in its subject matter to contemporary poetry and writing. For example, Margit Rowell and Rosalind Krauss identified the lizard in the foreground as "Merlin the wizard, fitted with his traditional conic hat," from Apollinaire's "The Decaying Magician."[33] Of course, since Miró spent a lot of his time reading between bouts of painting, it is not surprising for him to continue an imaginary dialogue with the authors he read in his work. Just as the flag forms a bridge to a cactus, so too, do the books he has brought to Montroig form an intellectual bridge back to Paris. At any rate, Miró's reading was not a relaxing activity. "In the room that serves as my studio I always have books, and I read during the breaks in my work. This demands a constant spiritual vibration from me."[34] It may well be that versions of particular characters and images from this reading matter often found themselves into Miró s paintings, however never in the form of an illustration. Rather, such

The Calculation, 1925
Oil on canvas, 195 x 129.2 cm (76¾ x 51 in.)
Paris, Musée national d'art moderne,
Centre Georges Pompidou

In the nineteen-twenties, a period of great importance for Miró, he produced the so-called "picture poems," in which the artist combined colors and words or numbers.

PAGE 36
Landscape, 1924/25
Oil on canvas, 69.5 x 64.5 cm (27¼ x 25½ in.)
Essen, Museum Folkwang

Figures from a new and mythical world appear in Miró's early and meticulous method of painting. The small and unprepossessing stand in the center: the ear of corn and the flower become as large as trees, the insects take on the role of people.

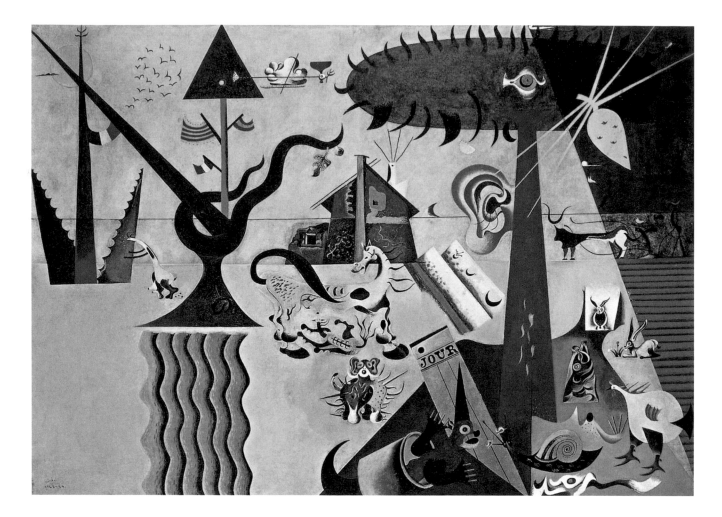

The Tilled Field, 1923/24
Oil on canvas, 66 x 92.7 cm (26 x 36½ in.)
New York, The Solomon R. Guggenheim
Museum

In the years 1923/24 Miró finds a new language
of imagery which translates the observation of
nature and the magical value of objects into a
system of signs and colors. The transition can
be seen in *The Tilled Field:* the objects have not
quite been transformed into an independent
world of signs.

characters were actually present in Montroig because Miró projected them
into the landscape with his thoughts. We know, too, that in a reverse process,
he brought small objects like toys, ceramic whistles, grass, and shells with him
from Spain back to Paris. Miró was constantly sorting his real and imaginary
acquaintances and worlds according to their possibilities of meaning.

Catalan Landscape (The Hunter) (ill. p. 39) of 1923/24 is almost the same
size as *The Tilled Field* (ill. p. 38), and it has some similarities in its placement
of forms. The subject matter that belongs to these forms, however, has been
somewhat changed. Obviously, even more of recognizable reality has been
left behind. The abstract circular base of the tree in *The Farm* (ill. p. 31) has
developed itself into the symbol for a tree – here as a large, light and slightly
irregular circle marked by a black point, a diagonal line and a single leaf.
It corresponds to the carob tree in *The Tilled Field* on the right side of the
painting, and also has an eye growing out of it. To the left, a stick figure re-
sembling the cactus-like tree in *The Tilled Field* indicates a human figure: the
hunter. He is wearing the traditional Catalan hat on his head and smoking a
pipe. Several small tongues of flame which issue from his pipe and his rifle,
as well as the flame next to his yearning heart give him a passionate aura. The
conical rifle that the hunter holds in the middle of the painting corresponds
to the chimney of the house in *The Tilled Field*. The spider/leaf object seems

to re-occur as a sun-egg in *The Hunter*. The fish is larger but still somehow missing its fleshy body. It is made up of a head with tongue, whiskers, an ear and eye, a bowel, a genital and a tail. These parts of its anatomy are connected by a straight line, much as are the remaining cones, triangles and circles of the rest of the composition. Once it is recognized as a sardine, however, its parts seem to be more cohesive. In fact, the whole painting begins to change when the characters are logically identified: centers form that are less a result of the composition than of the viewer's understanding of it. As a comparison of *The Tilled Field* and *The Hunter* demonstrates, Miró repeats and orders forms while changing some of their meanings. Yet above and beyond any anecdotal understanding is Miró's formal development. He has progressed even further in the direction of Picabia and Duchamp's machine art. "Less is more" was the credo of a whole generation of artists and architects aiming for clarity and impact. Miró follows this trend and empties out *The Hunter*, leaving only the most speaking of details. Again, he is looking for balance and a working together of parts. Because the parts float so freely against their background, *The Hunter* almost looks like one of the mobiles that Miró's friend, Alexander Calder, would construct several years later.

The background of Miró's paintings has become thin and transparent or smooth and opaque. Miró has abandoned his attempt to show real space or real things; instead, the qualities of nature herself come into effect in his

Catalan Landscape (The Hunter), 1923/24
Oil on canvas, 64.8 x 100.3 cm (25½ x 39½ in.)
New York, The Museum of Modern Art

The world of objects has been reduced to a few signs. Only the pipe of the hunter can be recognized, everything else is reduced to a few lines.

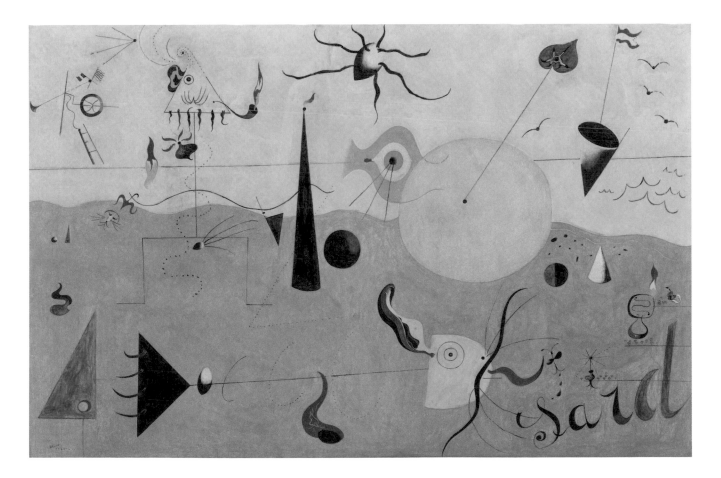

"How did I think up my drawings and my ideas for paintings? Well I'd come home to my Paris studio in the Rue Blomet at night, I'd go to bed, and sometimes I hadn't any supper. I saw things, and I jotted them down in a notebook. I saw shapes on the ceiling."
— JOAN MIRÓ

Harlequin's Carnival, 1924–25
Oil on canvas, 66 x 90.5 cm (26 x 35¾ in.)
Buffalo, Albright-Knox Art Gallery

The Surrealist championing of the sub-conscious begins to influence Miró. Remembered dreams become a source of inspiration in these small paintings.

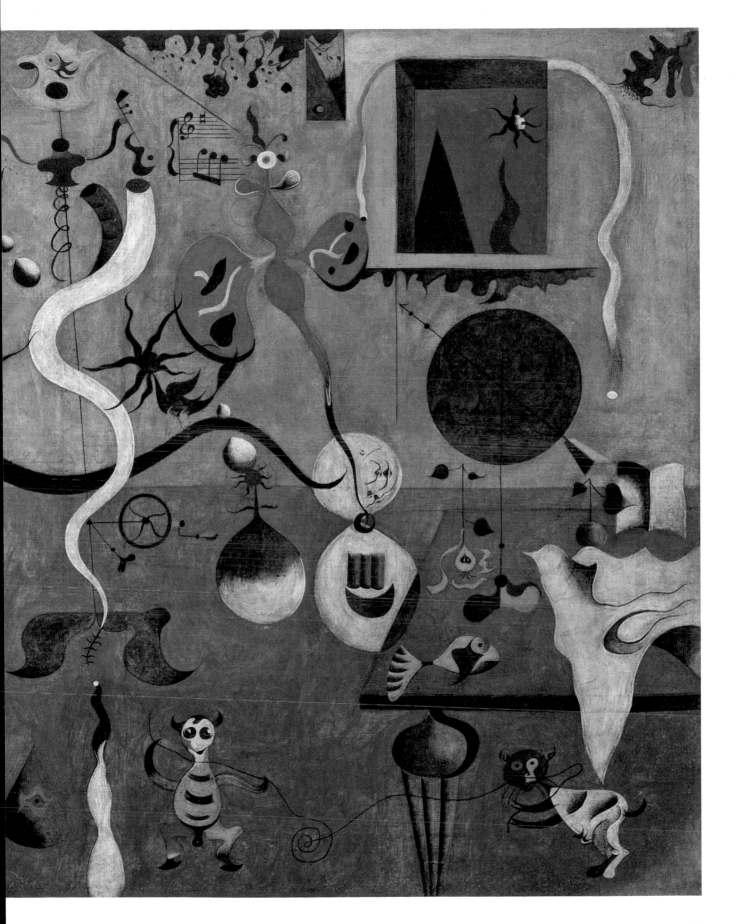

paintings. How can one show the brightness of sunlight streaming through a blue sky and reflecting from waves? By making the sky and sea a glowing, warm yellow. In a similar way, the ground has been thinly washed or rubbed with ocher and red, which become pastel tones through their thinness. Because the upper and lower halves of *The Hunter* and *The Tilled Field* are so close to each other in color and intensity, the canvas hardly appears divided into heaven and earth. Light is flooding the landscape, against which single forms may stand out. Particularly *The Hunter* has become flat, easily comparable to the pages of a book. Miró has finally reached what he was looking for in 1920 when he wrote, "I am working hard; going toward an art of concept, using reality as a point of departure, never as a stopping place."[35]

In 1924, the year André Breton published the first "Surrealist Manifesto," Miró made several more paintings in this vein. A relatively small canvas, *Harlequin's Carnival*, 1924–25 (ill. pp. 40–41), which Miró himself "illustrated" with a poetic text published in 1939 in the magazine *verve,* brought this phase to a climax. It continues the all-over distribution of weights and counter-weights in the form of amusing invented creatures celebrating an indoor carnival. A mechanical guitarist plays the music, while the others play games. The characters are beginning to look familiar: an insect jack-in-the-box has popped up out of a trunk, a fish lies on the table, a ladder, flames, stars, leaves, cones, circles, spheres and lines appear. Particularly the ladder has gained in importance since its introduction in the chicken coop of *The Farm* (ill. p. 31). It offers Miró a good opportunity of using connecting straight diagonal lines, while at the same time lending itself to poetic meanings. There is one detail of the carnival painting that does not seem "fantastical" or "imaginative," as Miró's paintings are usually called. The mildew and cracks on the walls under and around the window are shown as stains and decay. Of course, Miró was aware of Leonardo da Vinci's famous advice to use chance wall markings, marble striations, shadows or clouds as the beginning of an image, and he has begun to pay attention to just such forms here. Such inspiration was being discussed in the artistic circles around Miró.

Chance markings could be developed into things. Eventually, Miró would establish an irregular ground of color on his canvases and then look at the empty, flat, perhaps slightly transparent space and begin to people it with what the ground suggested to him. This also explains why the mildewed walls are explicitly included in *Harlequin's Carnival.* They represent one of the painter's starting points, an important source of inspiration that helped him to invent whole studios full of figures. Already the shapes on the wall next to the musical notes in the upper center of the painting have taken on the shape of leaves, vines and flames. But this does not mean that the paintings developed spontaneously. Preliminary drawings exist for Miró's paintings, and they often include written mentions of colors, the format of the finished canvases and their titles. Around 1924, the drawings were squared and transferred grid for grid onto the larger canvas. Despite all of his romantic fantasy, Miró was a careful and meticulous planner. His pictures existed in a preliminary form in his mind and on paper long before they hit

the canvas. Miró once wrote, "How did I think up my drawings and my ideas for paintings? Well I'd come home to my Paris studio in Rue Blomet at night, I'd go to bed, and sometimes I hadn't any supper. I saw things, and I jotted them down in a notebook. I saw shapes on the ceiling…"[36]

Hungry in bed: unrestful sleep with remembered dreams – the Surrealist championing of the sub-conscious also began to influence Miró. He often mentioned working from hallucinations caused by hunger, which shows how little money he had for food, even though he always seemed to have enough money for soap, shoe polish, paint and trips back and forth to Spain. His poverty was probably not entirely unwelcome in this respect, since the circle of intellectuals and artists he was in daily contact with were practising all kinds of extremes to reach the primal voice they pictured deep inside of themselves. Compared to the use of ether, cocaine, alcohol, morphium, or sex, Miró's hunger-hallucinations look almost like a monkish fasting. He was too deeply spiritual to destroy his own body, the vessel of that spirit. As the constant references to sensual and sexual organs in his paintings suggest, he fully enjoyed his own connection with nature.

Siesta, 1925
Oil on canvas, 113 x 146 cm (11½ x 57½ in.)
Paris, Musée national d'art moderne,
Centre Georges Pompidou

Here a depiction of the world has lost in significance. The structure of things – form, color, and line – is of supreme importance.

"I am working hard; going toward an art of concept, using reality as a point of departure, never as a stopping place."
— JOAN MIRÓ

ceci est la couleur
ce mes rêves.

Photo: This Is the Color of My Dreams, 1925
Oil on canvas, 96.5 x 129.5 cm (38 x 51 in.)
New York, The Metropolitan Museum of Art,
The Pierre and Maria-Gaetana Matisse
Collection

Confrontation with Surrealist poets in the years
after 1924 played an important role in Miró's
creative life. Words and sentences begin to people
his canvases: an attempt to transcend painting
and, at the same time, link it with poetry.

In a letter from Montroig he wrote, "During my off-hours I lead a primitive existence. More or less naked, I do exercises, run like a madman out in the sun, and jump rope. In the evening, after I've finished my work, I swim in the sea. I am convinced that a strong and healthy œuvre requires a healthy, vigorous body. I see no one here, and my chastity is absolute."[37]

In the fall of 1924, Miró met André Breton, Paul Éluard and Louis Aragon. "The First Surrealist Manifesto" was published in November. The following definition was contained in the lengthy manifesto: "SURREALISM, noun, masculine. Pure psychic automatism, by which one intends to express verbally, in writing or by any other method, the real functioning of the mind. Dictation by thought, in the absence of any control exercised by reason, and beyond any aesthetic or moral preoccupation.

ENCYCL. *Philos.* Surrealism is based on the belief in the superior reality of certain forms of association heretofore neglected, in the omnipotence of dreams, in the undirected play of thought."[38]

On one level, Surrealism (the word was first used by Apollinaire in his play "Les Mamelles de Tirésias" and as its subtitle in 1917) was a reaction against the unemotional, geometrical tendencies of art that began to win out in the nineteen-twenties. Although explicitly a literary movement, the visual arts

were mentioned in a footnote of the manifesto. Among the artists named were Paul Klee, Giorgio de Chirico, Marcel Duchamp, Francis Picabia, Man Ray, André Masson, and Max Ernst, as well as the "classics" Pablo Picasso, Henri Matisse, and Georges Seurat. Despite his exclusion of "aesthetic pre-occupations" – by which he might have meant conventional beauty –, André Breton did not intend to exclude painters, who were simply another hinge to expression. Miró and Masson were very probably the first painters to make the jump into free association, with Max Ernst following closely behind.

While the subject matter of *The Tilled Field* (ill. p. 38) and *The Hunter* (ill. p. 39) were already dream-like, influenced by the sub-conscious, they remained tightly constructed-looking images that had both taken the better part of a year to complete. In the summer of 1925, however, Miró created a work that seemed almost uncontrolled within the short space of just a few days. *The Birth of the World* (The Museum of Modern Art, New York) had a murky background resembling a streaky, steamed window, against which Miró had set a few sharply defined forms in black, white and the primary

Bathing Woman, 1925
Oil on canvas, 72.5 x 92 cm (28½ x 36¼ in.)
Paris, Musée national d'art moderne,
Centre Georges Pompidou

In this picture, whose blue background is reminiscent of seascapes, the line takes on an important function: it no longer delineates, surrounding frozen forms – it has itself become movement leading the eye of the observer through the picture.

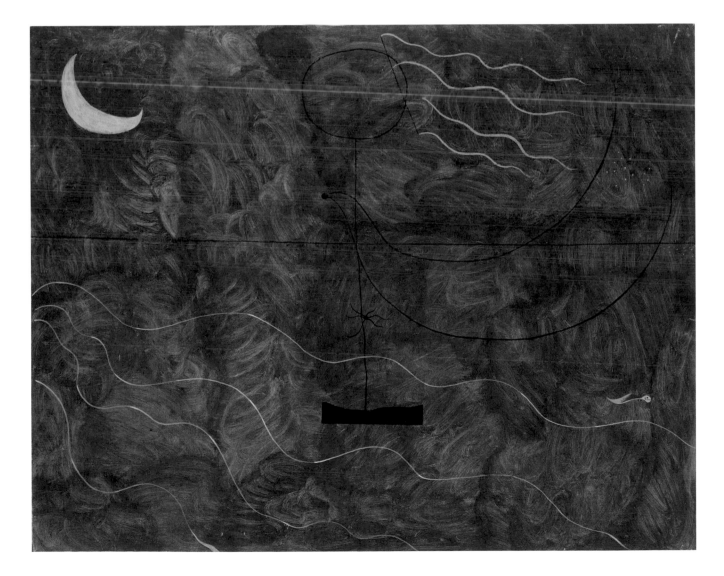

Person Throwing a Stone at a Bird, 1926
Oil on canvas, 73.7 x 92.1 cm (29 x 36¼ in.)
New York, The Museum of Modern Art

Lines continue to take up the narrative: a fantasy
figure throws a stone at a rooster. Lines suggest
the arm's momentum, the path of the stone and
the rooster's flight, they direct the readability of
the picture.

colors. The refers to the process of genesis itself, and here the recognizability
of that process is important. The painting quickly attained fame within the
circle of insiders who saw it in Miró's studio, including Breton, who later
likened its impact on artists to Picasso's *Demoiselles d'Avignon.* The paint-
ing's huge size magnified its unconventional stance; the new method of
applying paint had inevitably led to a larger format, and *The Birth of the
World* (*c.* 250 x 200 cm, 98½ x 78¾ in.) was Miró's largest picture to date.

In *The Birth of the World,* Miró began by artificially creating the possibility
of Surrealist "automatic" stimulus on the painting ground. He smeared the
canvas irregularly with glue sizing. Layers of transparent bister and black
glazes were poured and rubbed around, taking to the sizing with varying in-
tensities. Then ocher glaze was allowed to drip down from the top, forming
little rivulets. Miró also shook a brush dipped in ocher at the canvas to
achieve sprays of little spots. The triangular form with a tail was developed
from a large black area that seemed to Miró to need to be structured. (Miró:
"It might be a bird"). A red accent, the blue lines, the little man were added

one after another.[39] Automatic drawing and painting – letting the pencil or brush wander over a pictorial ground without a goal in mind – helped Miró find his motifs without looking for them. This relaxed the hold of the artist on his composition somewhat, even though he obviously still influenced it to a certain extent through his individual psychology. Yet as a comparison of *The Hunter* and *The Birth of the World* show, inspiration from the void brought about an entirely different kind of picture. It was a way of escaping one's own feeling for form by using chance spills, spots and shadings as a starting point. Any accidental form was a potential image. Of course, the accidental nature of the image's beginning were also a desired look.

Another work from 1925 remained almost completely empty. The indistinct blue background of *Painting* is relieved only by a tiny white circle in the upper left corner, and the artist's signature in the lower right corner. The poet Michel Leiris once wrote a long text about Miró's work in 1929, which calls up the spiritual and intellectual atmosphere of the period. It suggests a Buddhistic understanding of the world's entirety, which then focuses in on an small

Dog Barking at the Moon, 1926
Oil on canvas, 73 x 92.1 cm (28¾ x 36¼ in.)
The Philadelphia Museum of Art,
A. E. Gallatin Collection, 1952

The landscapes painted in 1926 show Miró as a colorist; both colors of the background are deep, forming an effective contrast for the primary colors red, yellow and blue.

and expressive detail of it. Obviously such an empty picture as the blue *Painting* from 1925 creates a space for meditation, but it needs a decisively set accent to convince the viewer that it has honed a sensual encounter to its sharpest point. In a letter to Leiris from 1924, Miró writes that the Japanese artist Hokusai "wanted to make a line or a dot perceptible, that's all."[40]

Clearly, Miró wants to create an effect in his painting similar to that of the terse Japanese poetry form of haiku, which concentrates on fresh and momentary perception. In the same letter to Leiris as above, Miró includes the phrase, "The eloquence of a cry of admiration made by a child in front of a blossoming flower." Between the years 1925 and 1927 – his last years in the Rue Blomet – Miró completed over one hundred and thirty pictures. (In the ten years before this, he had only executed a total of about one hundred pictures in all.) Most of the paintings were left untitled. The few titles Miró did allow were either invented by his poet friends after seeing the painting or were later derived from the phrases Miró actually painted onto his canvases, much as Picabia did. *Musique, Seine, Michel, Bataille, et moi* from 1927, refers somehow to walks along the bank of the Seine with Michel Leiris and Georges Bataille, whose interest in the body's openings was shared by Miró. Another work and one of Miró's most poetic, *Photo: This Is the Color of My Dreams* (1925; ill p. 44), also includes words, which have been carefully written in an effeminate calligraphy. Here Miró contrasts what the modern medium of photography and the traditional medium of painting can accomplish.

As time progresses, Miró's pictures become increasingly abstract, and his forms more organic. Often the images of this period appear haunted by the spirit of Paul Klee or Wassily Kandinsky. (Miró got to know Klee's work from a small gallery in Paris in 1925.) Groups of formally related works often came into being all at the same time, instead of being finished separately one after another. Despite the abstraction, it is often possible to recognize the traditional genres of landscape, still life or portrait painting within the images. Dotted, solid, curving and straight lines – and any combination thereof – play an important part in the balance of the paintings. The lines punctuate the pictures and direct their readability. In *Person Throwing a Stone at a Bird* (1926; ill. p. 46), they suggest the arm's momentum, the path of the stone and the rooster's fright, while also establishing a roughly triangular composition. The lines also are in keeping with the flat picture plane in Miró's paintings, which share many of the reductive aspects of printed comics. For example, *Landscape* (ill. p. 49), executed in Montroig in the summer of 1927, shows a humorous narrative situation expressed through highly simplified means.

In 1927, Miró left the Rue Blomet and moved to a studio near Jean Arp, Max Ernst, Paul Éluard, and René Magritte. Particularly Arp influenced Miró with the undulating silhouettes of his figures. Softened, organic forms became the contemporary idiom as opposed to the more geometric and angular vocabulary of Cubism's followers. Examples of these shapes are the rabbit (not duck) and balloon-like "flower" of *Landscape,* 1927. Such forms, whether defined by outlining or solid fields of color, were to accompany Miró for the rest of his artistic career. One year later, when Miró began to "redo" old mas-

ter paintings, he used his own color schemes and biomorphic forms that sometimes resemble Arp's.

In 1928, the thirty-five-year-old Miró, who had seen very little of the world up until that point, took a two-week trip to Belgium and Holland. He re-created several Dutch anecdotal paintings and portraits, which appear schematized and exaggerated like comic characters. Miró admired Dutch painting and did not intend to mock it. (One of Miró's free-floating comments was "The spiral staircase in 'The Philosopher' by Rembrandt.")[41] Instead, Miró adapted the seventeenth-century work to contemporary subjective reflection. Obviously, such a contrast of past and present styles agressively showed that painting had changed entirely and that certain things were no longer possible. On the other hand, Miró was certainly attracted to the symbolic details of Netherlandish painting, since it must have reminded him of the anecdotal and poetically symbolic character of his own work.

Dutch Interior I (ill. p. 51) and *Dutch Interior II* (ill. p. 50) present a re-creation of the old masters in a modern language of form and color. In this way, Miró clearly illustrates what is possible in painting and present – as well as what is no longer possible. Miró painted his "old master" paintings in his studio, using picture postcards from museum shops as a point of departure for his own versions of them, much as Pop artists would do. But Miró was also capable of using other printed material as a starting point. In a painting of

Landscape (The Hare), 1927
Oil on canvas, 129.6 x 194.6 cm (51 x 76½ in.)
New York, The Solomon R. Guggenheim Museum

In 1927 Miró moved into a studio near Jean Arp, Max Ernst, Paul Éluard, and René Magritte. Particularly Arp influenced Miró with his undulating silhouettes and the organic forms of his figures. The hare in this picture is one example of this influence.

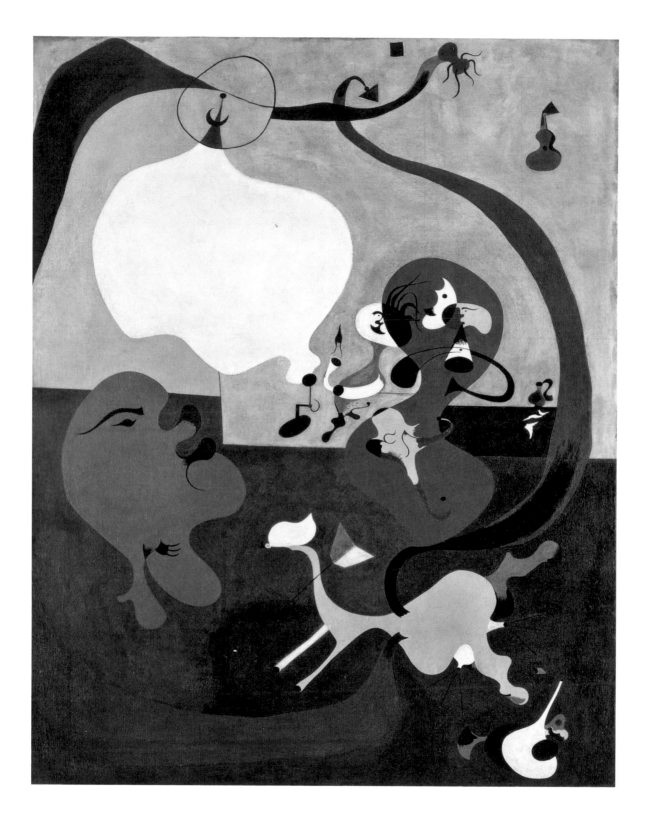

Dutch Interior II, 1928
Oil on canvas, 91.8 x 73 cm (36¼ x 28¾ in.)
New York, The Solomon R. Guggenheim Foundation, Peggy Guggenheim Collection, Venice

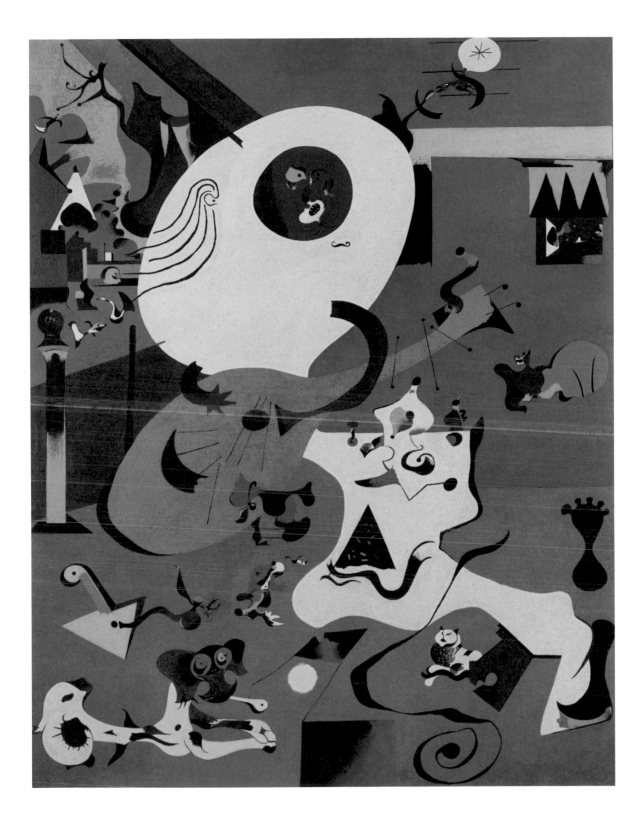

Dutch Interior I, 1928
Oil on canvas, 91.8 x 73 cm (36¼ x 28¾ in.)
New York, The Museum of Modern Art,
Mrs. Simon Guggenheim Fund

1929, he chose a Spanish advertisement for a German diesel motor to create *Queen Louisa of Prussia*[42] (ill. p. 53).

Miró saved the copy of advertisement, upon which he wrote, "Pour la Reine." The general shape of the motor resembled an upright female figure with protuberant breasts, a long skirt and a very small head. She has been placed upon a canvas vibrant with contrasting colors arranged in an exceedingly spare and unusually spatial situation. There is probably an explanation for this. The "Queen" complements the emptiness of room with her body in almost exactly the same way as did Georg Kolbe's realistic female nude statue in Mies van der Rohe's Barcelona Pavilion of the same year. (Miró was visiting Barcelona in February and September of 1929.) The composition of Miró's painting bears a close resemblance to that of the most well-known photograph of the Kolbe sculpture poised above the water surface in the courtyard of Mies's building. Even the circular arm movement of Kolbe's

Portrait of Mrs Mills in 1750 (after Constable), 1929
Oil on canvas, 116.7 x 89.6 cm (46 x 35¼ in.)
New York, The Museum of Modern Art, James Thrall Soby Bequest

This portrait is one of a series of *Imaginary portraits* done according to historical portraits. As with the *Dutch Interiors,* Miró transforms them into his own, fantastic form language.

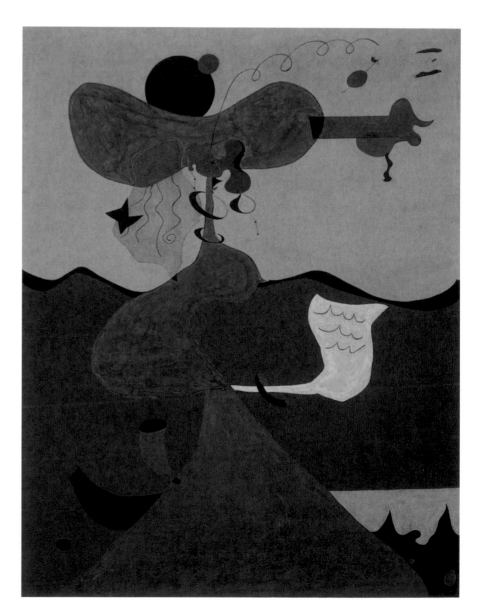

figure seems to repeat itself in the breast-like bulges of the queen. In a kind of blind intuition, Miró lighted upon the image of the epoch that allied opposites: the temple of abstract International Style architecture that Hitler would declare to be degenerate with the type of realistic sculpture that the Nazis supported. Although the original shape of the diesel motor is no longer recognizable in the Prussian queen, Miró used this machine in a Dadaistic sense that assumes a somewhat sinister and martial aspect. The strong color contrasts and the figure's floating quality emit an unspoken tension that makes this image one of Miró's strongest paintings.

In 1928 and 1929, Miró painted several metamorphoses of existing female portraits, using two-dimensional sources as inspiration. Perhaps he only had eyes for one woman in real life. In October of 1929, Joan Miró was married to Pilar Juncosa. Nine months later in July of 1930, his first and only child was born in Barcelona, a daughter whom he gave the name of his sister and mother, Dolores. In August, the dictatorship of Primo de Rivera was ended and during the following year a young Spanish Republic was born as well.

Queen Louisa of Prussia, 1929
Oil on canvas, 82.4 x 101 cm (32½ x 39¾ in.)
Dallas, Meadows Museum, Southern Methodist University

A Spanish advertisement for a German diesel motor was the starting point for this picture.

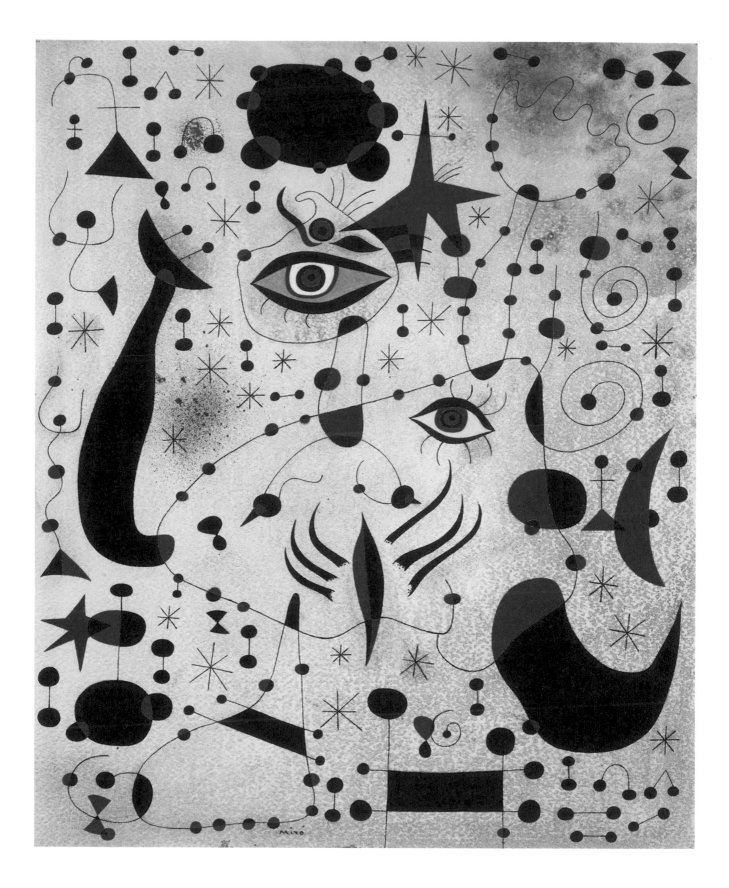

New Constellations

After the Second Spanish Republic had been declared, the problem of Catalonia's nationality became partially solved. In September of 1932, the region succeeded in acquiring autonomic status with its own government, a parliament and extensive rights in running its own bureaucracy. This was also the year that Miró decided to return to Barcelona, although for mostly financial reasons. In Paris, the Surrealist group had floundered and split. Miró had gradually drifted away from them, their disagreements and politics. With a wife and child, Parisian life had become decidedly more difficult and more expensive, its social life distracting rather than inspiring. In Barcelona, Miró and his family lived in his childhood home, with trips to Montroig and occasionally to Paris. The art market was suffering badly from the world economic crisis and by 1932, Miró's Parisian gallerist, Pierre Loeb, could no longer buy or sell all of his paintings. Thus Loeb asked Pierre Matisse in New York to help by taking on half of Miró's production in return for an artist's monthly salary. This must have been discouraging for the almost forty-year-old Miró. Although Miró had become successful in intellectual and artistic circles, and had been given one-man shows and included in group exhibitions, although he had done book illustration and worked as stage and costume designer, he still could not live from his art. By returning to his mother's house in Barcelona (his father had died in 1926), he could at least better his financial state somewhat.

As many of his contemporaries were also doing, Miró continued his experiments with media and materials. He made assemblages from found materials and objects; he painted, drew and collaged on paper, masonite, wood, sandpaper, copper. He was a painter who was trying to get beyond painting, to escape from purely visual experience and to lead his art in a more conceptual direction with a systematic approach. It would be hard to pinpoint exactly where he was trying to go, since he really did not even know himself. At times he felt destructive and angry about the limitations of painting. In 1933, working in the attic of his mother's house, he made a series of eighteen paintings that used collages as models. Similar to his choice of the diesel motor for

Ciphers and Constellations,
in Love with a Woman, 1941
Gouache and terpentine paint on paper,
45.6 x 38 cm (18 x 15 in.)
The Art Institute of Chicago,
Gift of Mrs. Gilbert W. Chapman, 1953.338

From January 21, 1940 to December 12, 1941 Miró worked on the series entitled *Constellations,* a small series of 23 gouaches and turpentine-color paintings on paper. A host of stars, suns and moons covers the surface linked by a network of lines.

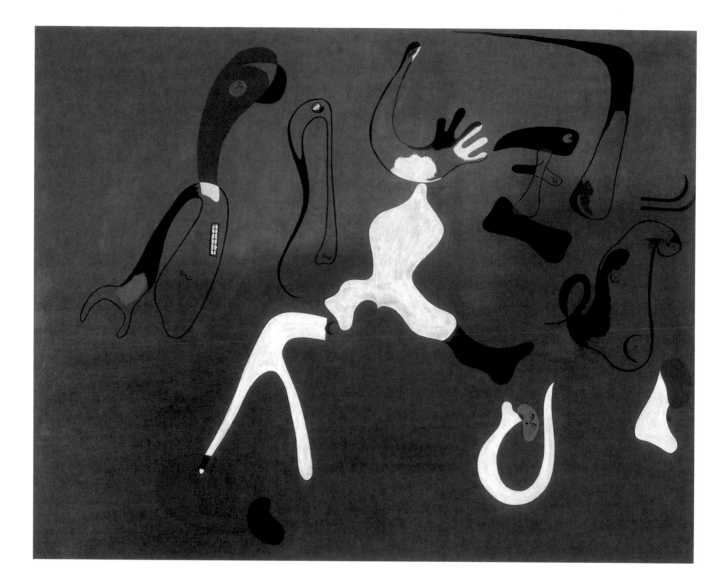

Composition, 1933
Oil on canvas, 130 x 162 cm (51¼ x 63¾ in.)
Berne, Kunstmuseum Bern

the *Queen Louisa of Prussia* (ill. p. 53), he again took pictures of machines and everyday objects from catalogues and newspapers and arranged and glued them onto a paper background. Miró saved the collages, yet they were not finished images in themselves, but preliminary states of paintings much as drawings might be. (Picasso also used collages this way.) According to Jacques Dupin, Miró purposely took non-poetic objects to force himself to work "against the grain" by denaturing the technoid objects into signs and figures of his organic world.[43] Miró was trying to halt his production somewhat and return to a constructed image, while preserving his inventive powers – perhaps he had grown distrustful of his own inflationary production. Doubtless the original meaning of the tools and machines remained somehow connected to the final image, although they were no longer recognizable in their original form. Perhaps one should imagine them as blanketed silhouettes of real things that assume an incognito. Miró seems not to want to lose touch with the cold technological world and at least preserve its memory, if not its face, in his work.

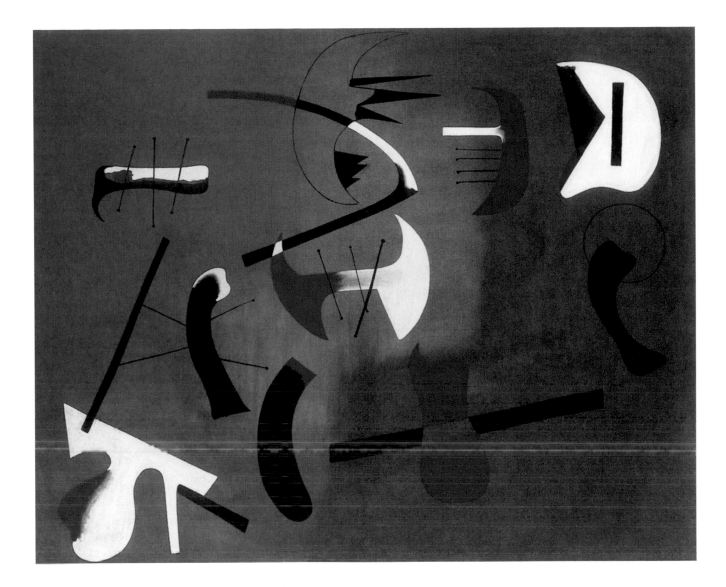

Although his work of the nineteen-thirties was all in all less anecdotal, with a broader, simpler vocabulary of signs, Miró remains obligingly readable. For example, *Painting* of 1933 (ill. pp. 58-59) has made the collaged objects into little creatures that correspond to the original illustrations of tools roughly in shape, but not in meaning. Perhaps the small implements expanded upon here were related to the stage props Miró had designed for the Russian Ballet's production of *Children's Games* that he worked on a year before. (Léonide Massine had hired him to design the curtain, sets, costumes and accessories of the dancers. The art work actually influenced the choreography.) By making the tools of *Painting* into small beings on a stage, they became dancers themselves. *Painting* from 1933 might not seem particularly aggressive, yet Miró, who had boxed for a while with Ernest Hemingway, used fighting terms to describe his work around this time, including the ballet job of 1932. "I am treating everything the same as my latest work: the curtain, the first 'hook' that hits the audience, like this summer's paintings, with the same aggressiveness and violence. This is followed by a rain

Painting, 1933
Oil on canvas, 130 x 162 cm (51¼ x 63¾ in.)
Prague, Národní Galerie

Painting, 1933
Oil on canvas, 130.4 x 162.5 cm (51¼ x 64 in.)
Private collection
The picture belongs to a series of large-format
paintings produced from paper collages (cf. ills.
pp. 56 and 57). The cut-out collage parts were
transformed by Miró into bright colors.

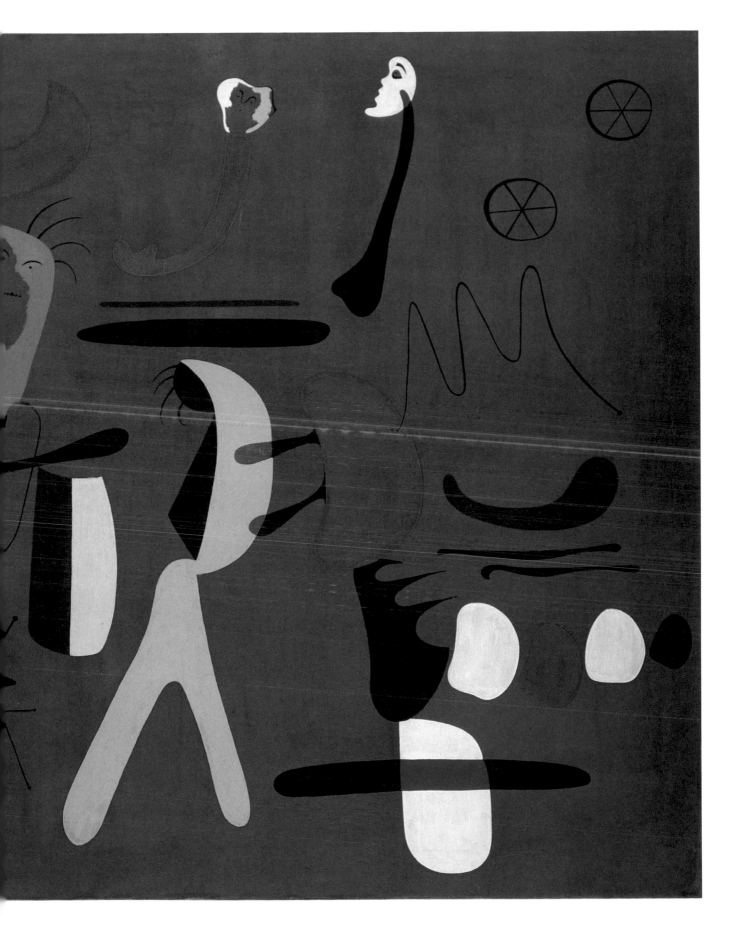

Painting, 1934
Oil paint, graphite, and collage of cut paper on
sandpaper, 36.2 x 23.5 cm (14¼ x 9¼ in.)
Philadelphia Museum of Art,
A. E. Gallatin Collection

The small picture is painted on sandpaper, illus-
trating Miró's preference for unusual surfaces.
The soft forms are reminiscent of contemporary
paintings by Jean Arp and of his own work of
the previous year.

of swings, uppercuts, and rights and lefts to the stomach, and throughout
the entire event – a round that lasts about twenty minutes – objects keep
appearing, moving and being dismantled on stage."[44]

Aggression, dismantling changes, sudden appearances and disappearances
of reforms also marked, or rather marred, the first years of the Republic.
However, Miró, who lead a peaceful and privileged life within his family,
could still paint an image like the large, brilliantly colored *Painting (hiron-
delle amour)* (ill. p. 61) in the winter of 1933/34, which was the design for a
wall tapestry. Miró again employs poetic suggestions. Giacometti, who was
a close friend of Miró around the time this picture was executed, later said,
"For me, Miró was synonymous with freedom – something more aerial,
more liberated, lighter than anything I had ever seen before."[45]

Yet as time went on, even Miró could not help but see the political devel-
opments around himself as a frightening whirlpool that might enlarge and
suck everything down. His art and his letters voice these fears. The precari-
ous foundation for political reform in Spain is revealed clearly by the civil-
war-like events in October of 1934. There had been an election victory for
the conservatives, which was answered by the Left with general strikes. In
Catalo-nia and Asturia, the Spanish government reacted by declaring a state
of war, which led to a social revolt that was quickly crushed in Catalonia.
In Asturia, however, about 30,000 miners resisted the Africa Army and the
Foreign Legion commanded by Francisco Franco for two weeks. After the
revolt ("Unite, proletarian brothers!") had been broken, about 10,000 "sus-
pects" were arrested. The young Second Spanish Republic was doomed by
the oligarchy's lack of support, and its unwillingness to give up its privileges,
and by the desertion of the agrarian and industrial working classes, who
were disappointed in their essentially unchanged situations. The intended
balance that could not be accomplished through peaceful, reformatory means
became a violent see-sawing of reactions that ended 1936 in civil war.

Miró's part in this world was that of an observer; as always, he did not
openly talk about the crisis situation in Spain. Instead, he began what he
called his "wild" pictures. *Woman* of 1934 (The Art Institute of Chicago) is
typical of a number of images of pained, startled or beast-like individuals,
particularly women, executed during this period. Unlike earlier figures
which were almost always composed of monochrome building parts,
Woman has been shaded, suggesting something more of volume, but also
of discord. Her pelvis is a greying white with a tipped sexual opening and a
tailbone, her upper torso an illogical asymmetry of intensive color patches
that vaporize into blues and whites, as if the figure were expelling a cry.
(This change in the use of color may have been influenced by the medium
of pastel, which Miró used for *Woman* and a number of pictures to follow.)
Her arms clamp her into her own suffering, while her teeth make her seem
out of control, certainly not an easy creature to calm and help. She once
stood alone on a background that must have seemed too empty and solitary
to Miró, for he filled in the space around her and between her arms and
body with rough squarish groupings of scratch-like, thin, dark lines. These

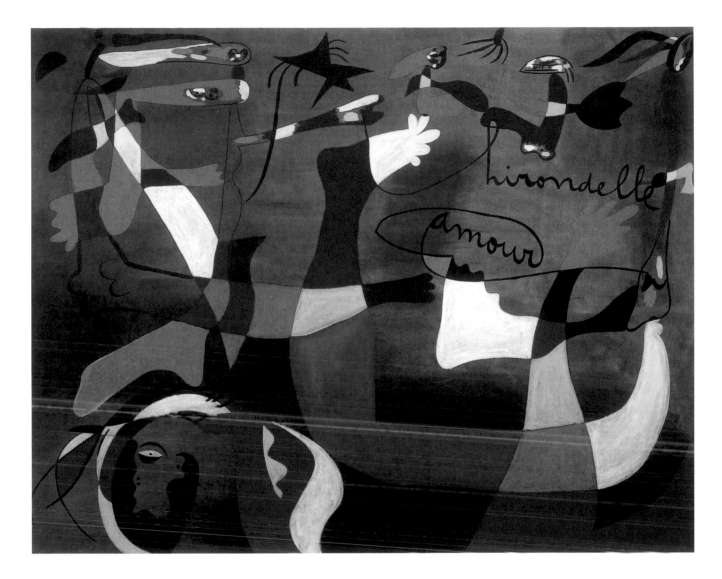

space fillers are made of mostly vertical and horizontal lines that slice through each other at approximately right angles. The line groups remain transparent, but suggest buzzing, shadowy centers around the woman.

Other images, like the oil paintings *Man and Woman in Front of a Pile of Excrement,* 1936 (ill. p. 65) or *The Farmer's Meal,* 1935 show more characters involved with each other in a science-fiction-like landscape or windowless interior space. Their inventive forms, heightened by extreme color contrasts, express hysteric urges and reactions. Here Miró reveals the kind of unsurpressed associative *Gestalt*-perception that small children have before they learn to rationally disassociate: a hand may become a hook, a hammer and a knife, while cheeks may become tears, jowls and ears. In general, art historians interpret the emotional ambiance of the "wild" pictures as seismographic, communicating the shudders of pre-civil war Spain. Sometimes Miró projects this tension onto naked male and female figures, so that the problem seems to exist between the sexes and not between classes and political parties. Never do the "wild" pictures address specific events or issues, which holds them at least an arm's length away from becoming critical political art.

Painting (Swallow/Love), 1933/34
Oil on canvas, 199.3 x 247.6 cm (78½ x 97½ in.)
New York, The Museum of Modern Art,
Gift of Nelson A. Rockefeller

As early as the nineteen-twenties, Miró had begun to experiment with picture poems. Here figures and word elements are linked by twisting lines: the word "hirondelle" and "amour" stand in front of the blue background as if written in the sky by an aeroplane or by the flight of a swallow. The free distribution of parts of the body and forms cause a feeling of openness as if the figures are in free fall.

Rope and People I, 1935
Oil and rope on cardboard, stuck to a wooden
board, 104.8 x 74.6 cm (41¼ x 29¼ in.)
New York, The Museum of Modern Art,
Gift of the Pierre Matisse Gallery

This picture begins Miró's so-called "wild pic-
tures" of the mid-nineteen-thirties which show
a horror scenario. Man Ray points to the fact
that Miró's use of the rope could have something
to do with his own frightening experience of a
threatened hanging in his studio (see comment
below Man Ray's portrait of Miró on p. 20).

PAGE 63
Composition with Ropes, 1950
Oil, ropes and plaster on canvas,
99 x 76 cm (39 x 30 in.)
Eindhoven, Stedelijk Van Abbe Museum

Here the pieces of rope have been bound together
to make large knots. They make a three-dimen-
sional relief out of the picture, making it appear
as a precursor of the later *Combine Paintings* of
Robert Rauschenberg.

Rope and People I from 1935 (ill. p. 62) is a collage that continues the
"wild" pictures. Four vertical figures fill the vertical image: a man biting
his own hand, a rope looping out towards his neck and two bare-breasted
women. Miró, who saw the rope as constricting and hurting the figures,
used it as a symbol of violence. In his autobiography, Man Ray wrote that
Miró's use of rope had to do with his own frightening experience of a prank-
ish threatened hanging in Max Ernst's studio. In contrast, Jacques Dupin in-
terprets the rope as a helpful farmer's tool for hauling and tying. Whatever
its implications may be, the linear qualities of the rope are at home in Miró's
images. Often the lines on Miró's paintings, drawings and collages look as if
they had been traced from strings that were dropped and pushed into place.
Miró never mentioned doing this, but Antoni Gaudí had used string and

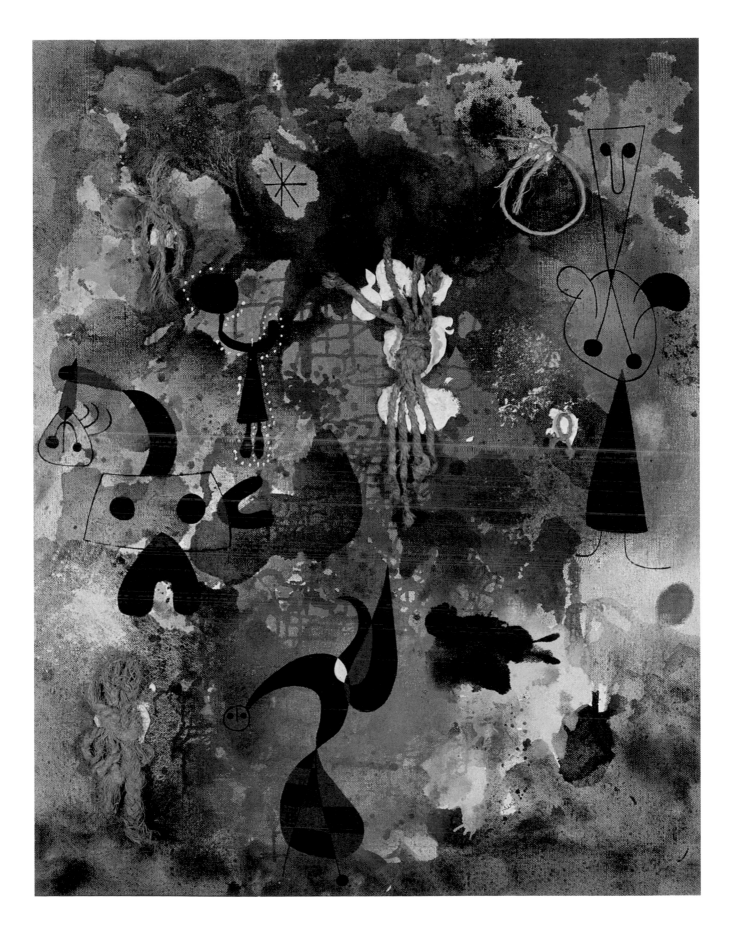

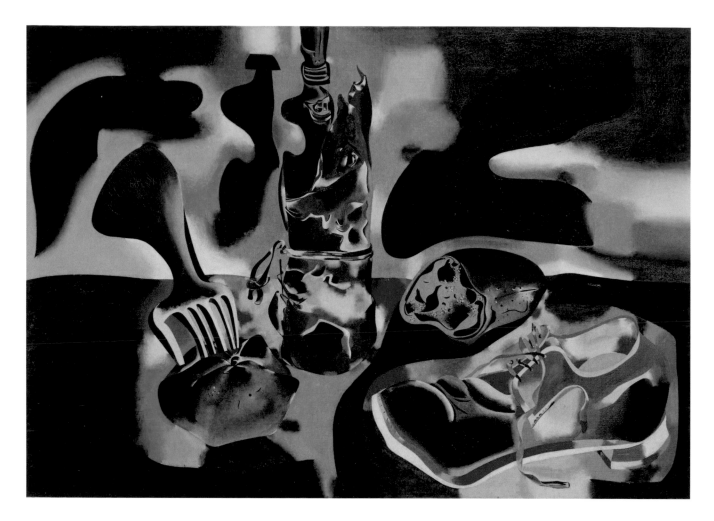

Still Life with Old Shoe, 1937
Oil on canvas, 81.3 x 116.8 cm (32 x 46 in.)
New York, The Museum of Modern Art,
Gift of James Thrall Soby

Everyday objects serve as the motif: a bottle, a
loaf of bread, an apple (with a fork stuck in it),
and the shoe mentioned in the title. The glow-
ing color transforms these simple objects into
an apocalyptic vision.

PAGE 65
Man and Woman in front of a
Pile of Excrement, 1936
Oil on copper, 23 x 32 cm (9 x 12½ in.)
Barcelona, Fundació Joan Miró,
Gift of Pilar Juncosa de Miró

A strong light-dark contrast lends an unreal
and close atmosphere to the scene. The pile of
excrement of the title stands on the right of the
picture like a statue.

wire to illustrate his building ideas in model form. Clearly the fluidity of
the material rope is "tied" to the expressive flowing line. The thickly wound
rope in *Rope and People I* is roughly anthropomorphic, with its twists and
loops. It represents a character with which the human figures must interact.
Rope and People II tips the canvas into a horizontal format, while the rope
remains a middle point. The small figures made of lines, wipes, strokes and
blots are distributed around it to create a balance. These strange canvases
with their interest in the thick material of rope almost seem like precursors
of Robert Rauschenberg's *Combine Paintings.*

 After the outbreak of the Spanish Civil War in July 1936, Miró returned
to Paris where his family joined him one month later. He was to remain in
exile in France until 1940. At first, without a studio or a place to live, Miró
was forced to stay in a hotel. Because he could not paint, he began a journal
in which he wrote poetry and prose. Margit Rowell wrote about his poems,
"Miró's images are a painter's images: disjunctive, frontal and colorful. It is
clear that in both painting and poetry his process was identical. Indeed
one might call these verbal images *poèmes-tableaux,* rather than *tableaux-
poèmes.*"[46] Examples of this poetry show it to resemble some of the best
Surrealist writing by authors like Robert Desnos and Benjamin Péret, two of
the poets he knew since his days in the Rue Blomet. Reading some of these

poems does much to illustrate the associative freedom, the sexual and scatalogical overtones that distinguish Miró's painting.

By the beginning of 1937, Miró realized that he would not be returning to Barcelona for some time. Although he was soon able to move to a small apartment, his working conditions in Paris were very limited and he felt he could not continue the series of paintings that he had planned to develop. In January 1937 he wrote to Pierre Matisse, "Given the impossiblility of going on with my works in progress, I have decided to do something absolutely different; I am going to begin doing very realistic still lifes (…) I am now going to attempt to draw out the deep and poetic reality of things, but I can't say whether I will succeed to the degree I wish. We are living through a terrible drama, everything happening in Spain is terrifying in a way you could never imagine (…) All my friends advise me to stay in France. If it were not for my wife and child, however, I would return to Spain."[47]

Miró began to work on a still life that he would come to consider one of his most important paintings (ill. p. 64). He set up an empty gin bottle wrapped in a piece of paper with a string around it, a large apple with a fork stuck into it, a crust of black bread and an old shoe on top of a table and

"I had this unconscious feeling of a threatening catastrophe. Shortly before the rain falls, aching limbs and suffocating closeness. It was more a physical than a spiritual feeling. I had a premonition of a catastrophe that would soon happen, but I didn't know what it would be: it was the Spanish Civil War and the Second World War (…) Why I gave it this title? At this time I was fascinated by the words of Rembrandt, 'I find rubies and emeralds in the dung heap'."

— JOAN MIRÓ

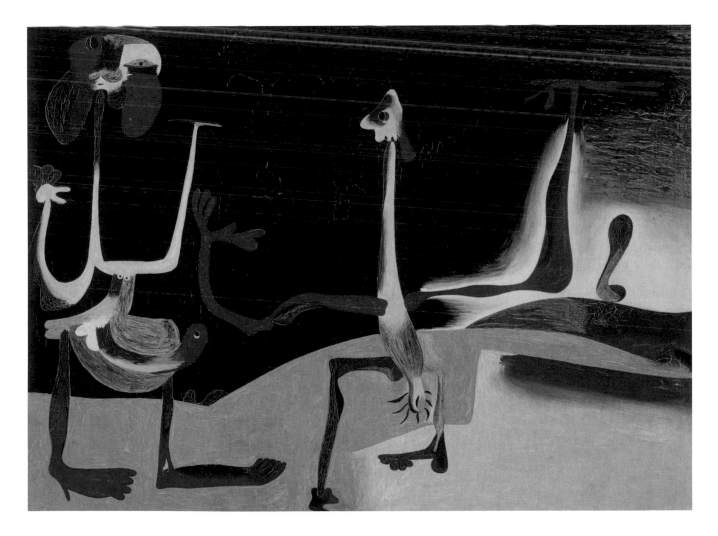

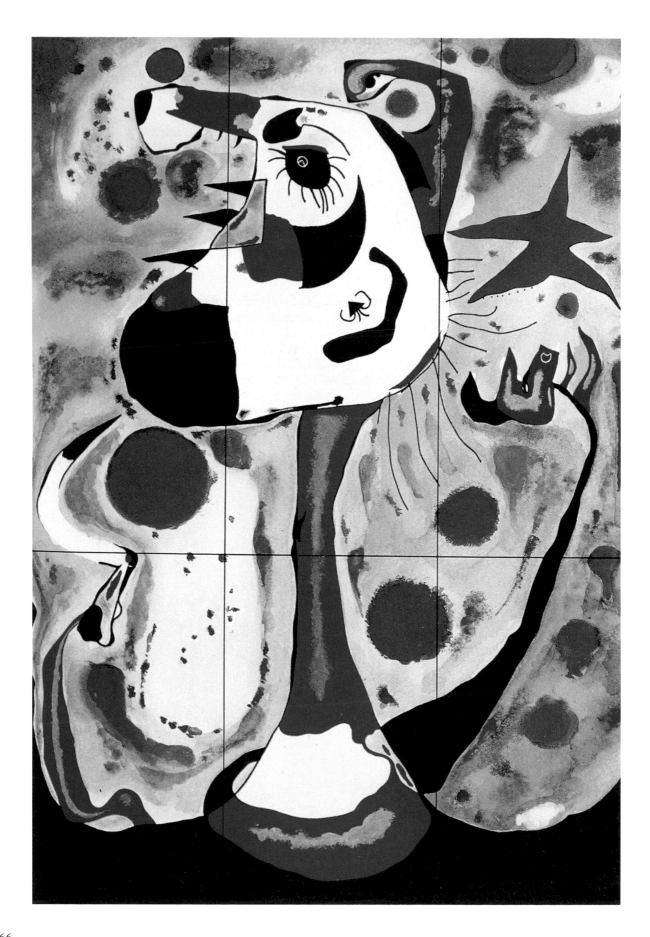

spent five months painting them. Since he had no studio, he worked on the mezzanine of Pierre Loeb's gallery. He also spent time drawing nude models at the Académie de la Grande Chaumière. *Still Life with Old Shoe* recalls some of Miró's early work in its recovered realism. Why did Miró desert the more individual and personal sign language that he had established over the years? Without becoming a social realist, he was trying to create a more readily understandable image of humble objects that stood for humble people. Of course, the objects do not necessarily belong together on a table top, but they do express a sense of poverty and anger, of loss and desertion. Heavy, predominant blacks and dark greens crowd in on the objects that have been modelled with intense colors, as if they were burning in a dark night. Miró wrote that he was looking for "profound and fascinating reality" and trying to create a work that could "hold up against a good still life by Velázquez."[48]

1937 was also the year of the Paris World Fair. The struggling Spanish Republic belatedly decided to participate and show what it had already

PAGE 66
The Reaper, 1937
Oil on Celotex, 550 x 365 cm (216½ x 143¾ in.)
(lost)

Miró painted this mural for the pavilion of the Spanish Republic at the Paris World Fair. The monumental portrait of a Catalan peasant with a sickle in his clenched fist stands as a symbol of the revolutionary.

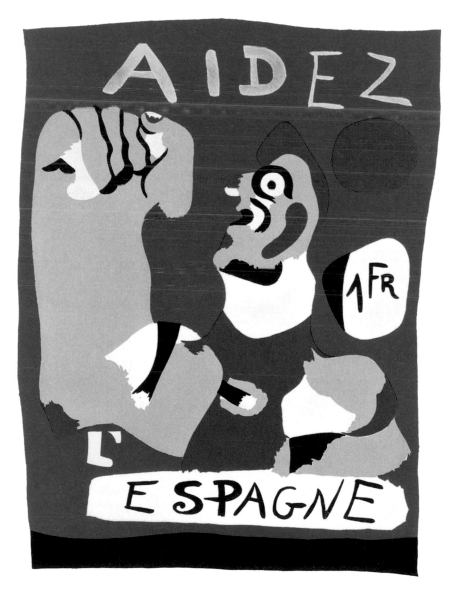

"In the present struggle I see, on the side of the Fascists, powers that have become outdated, on the other side the people, whose great creative potential lends a strength to Spain which will amaze the world."

— JOAN MIRÓ

Aidez l'Espagne (Help Spain), 1937
Silk-screen painting, 24.8 x 19.4 cm (9¾ x 7¾ in.)
Private collection

This poster was designed by Miró in support of the Spanish struggle for freedom. The figure clenches its hand to form a huge fist: crude strength against the enemies of liberty.

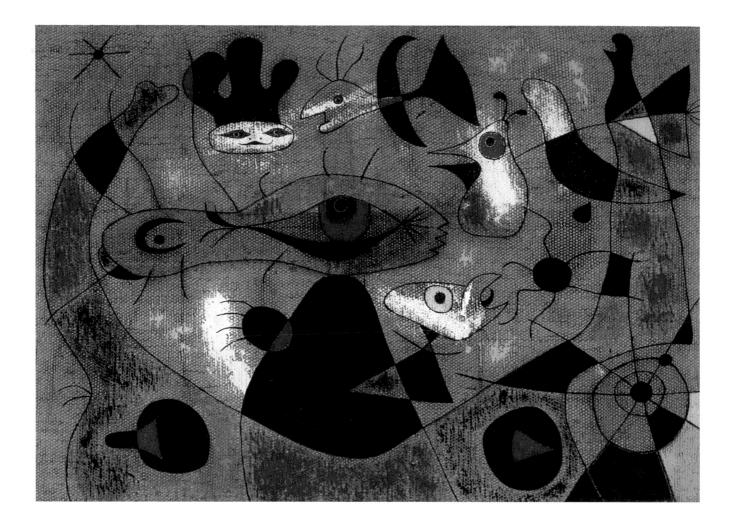

A Dew Drop Falling from a Bird's Wing Wakes Rosalie, Who Has Been asleep in the Shadow of a Spider's Web, 1939
Oil on basketweave fabric, 65.4 x 91.7 cm (25¾ x 36 in.)
Iowa City, The University of Iowa Museum of Art, The Mark Ranney Memorial Fund

The two pictures on these pages belong to the so-called burlap series: Miró developed his typical world of figures on the coarse material, giving them poetic titles. At this period Miró was leading a secluded life dedicated to his art.

PAGE 69
The Escape Ladder, 1939
Oil on basketweave fabric, 73 x 54 cm (28¾ x 21¼ in.)
Private collection

The escape ladder is a motif which can be repeatedly found in Miró's work. In the days of the onset of the Second World War, it may be understood as a metaphor for the search for an escape from threatening world events.

accomplished, but also the tragic plight in which it found itself. The Spanish Pavilion of 1937 was a successful marriage of propaganda and avant-garde art and architecture, featuring the work of Picasso, Miró, Julio González, Alberto Sánchez Pérez, and Alexander Calder. The pavilion itself was designed by Luis Lacasa and Josep Lluís Sert. The artists and co-ordinators of the project worked together at a feverish pace to complete the building, with its documentary photomontages, sculpture and paintings. It was for this building context that Picasso painted his *Guernica* (Museo Nacional Centro de Arte Reina Sofía, Madrid), which referred to the first aerial bombing of defenseless civilians in Spain. The architect Sert convinced Miró to cover a wall that stretched over the height of two floors – Miró had never painted anything of this size before. He decided to make a monumental portrait of a Catalan farmer holding a sickle in his raised fist. *The Reaper* (ill. p. 66) is clearly related to the "wild" paintings, and it closely resembles the design for a fund-raising stamp and poster against the Spanish Civil War that Miró drew upon request in 1937 (ill. p. 67). *The Reaper* had been the symbol of Catalonia's loss of freedom to the bureaucratic centrism of an imperial Castile since the seventeenth century. The Celotex wall panels of *The Reaper* disappeared or were destroyed after the pavilion was disassembled. Miró,

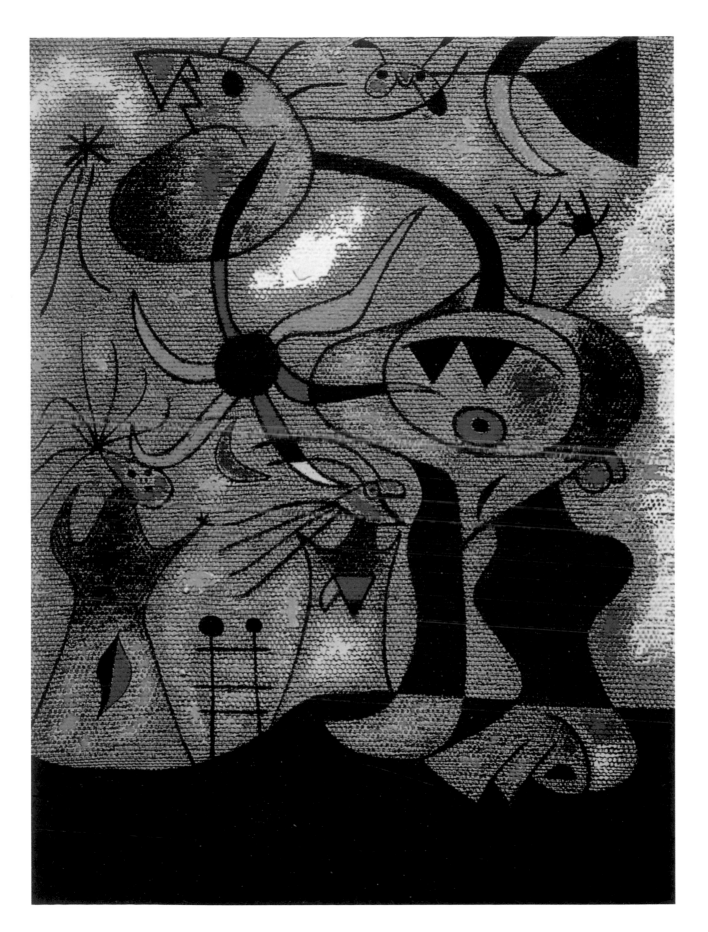

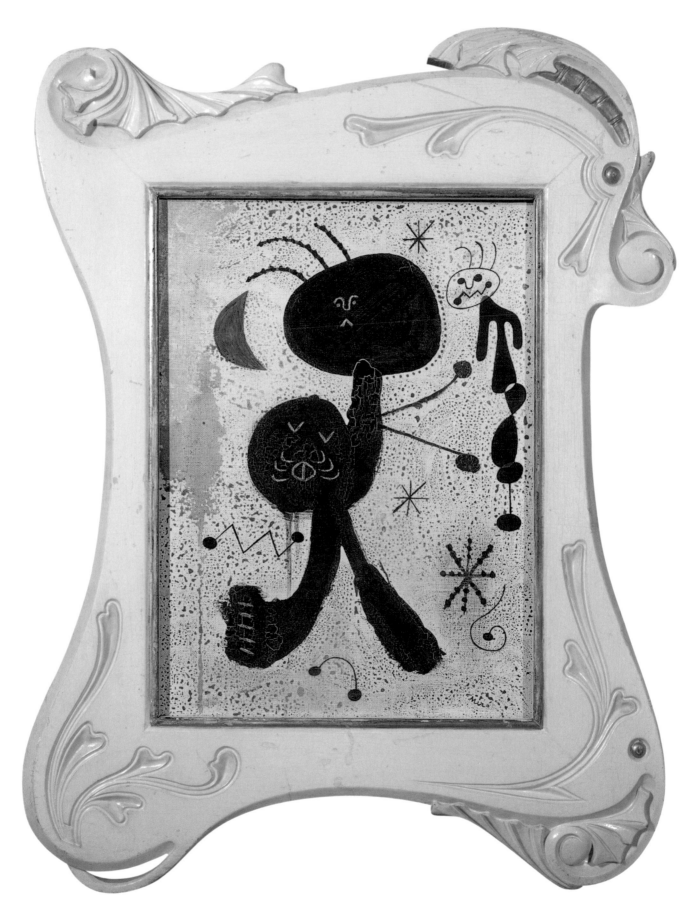

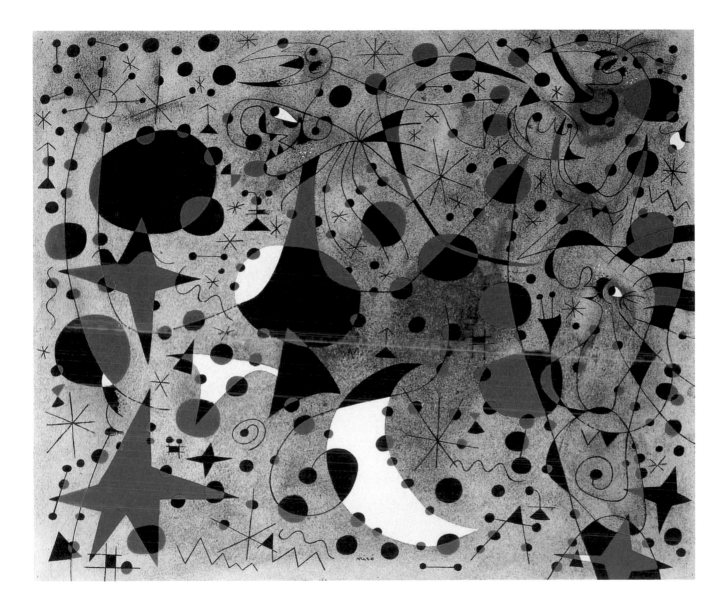

PAGE 70
Painting, 1943
Oil and pastel on canvas,
40 x 30 cm (15¾ x 11¾ in.)
Barcelona, Fundació Joan Miró

After the beginning of the war, Miró began a series of paintings, the *Constellations.* Stars, moons, suns and figures are linked to form a delicate and close-knit "cosmic" network of signs. He systematically alters the colors on their crossing of the lines: red becomes black, black becomes red. The result is a pulsating of the forms in the background. Miró continually emphasizes his difficult search for compositional balance while working on this series.

The Nightingale's Song at Midnight
and the Morning Rain, 1940
Gouache and terpentine paint on paper,
38 x 46 cm (15 x 18 in.)
Private collection

however, painted at least nine other works during that same year on Celotex, which was a main building material of the pavilion.

It is strange that while the other artworks were saved or recovered, Miró made no attempt to save *The Reaper*. (It would not have been unlike the artist to use the marks on the disassembled panels as the starting points for new compositions.) It was the *Still Life with Old Shoe* (ill. p. 64) and not *The Reaper* that Miró would later consider his equivalent to *Guernica*. As can be read in the Catalan notebooks from 1940 and 1941, Miró was planning a large tragic painting that would be an answer to *Guernica,* but without what Miró considered Picasso's melodrama. It was a work that never got painted.

The *Self-Portrait* of 1937 shows Miró was "seeing stars" and he was soon to begin a series of paintings that came to be known as the *Constellations* (ills. pp. 73, 74). At Varengeville-sur-Mer in Brittany, a sort of artist's colony where one of Miró's benefactors, the American architect Paul Nelson, had a house, Miró began a new stage in his work that had its source in music and nature.

In an interview with James Johnson Sweeney in 1948, Miró recalled, "It was about the time the war broke out. I felt a desire to escape. I closed myself within myself purposely. The night, music, and the stars began to play a major role in suggesting my paintings. Music had always appealed to me, and now music in this period began to take the role poetry had played in the early twenties – especially Bach and Mozart when I went back to Majorca upon the fall of France. Also the material of my painting began to take a new importance. In watercolors I would roughen the surface of the paper by rubbing it. Painting over this roughened surface produced curious chance shapes. Perhaps my self-imposed isolation from my colleagues led me to turn for suggestions to the materials of my art. First to the rough surfaces of the heavy burlap series of 1939 (ill. pp. 68 and 69); then to ceramics – (…) After the heavy burlap series of 1939 I began a group of gouaches which were shown here in New York at the Pierre Matisse Gallery just after the war – an entirely new conception of things…They were based on reflections in water. Not naturalistically – or objectively – to be sure. But forms suggested by such reflections. In them my main aim was to achieve a compositional balance. It was very long and extremely arduous work. I would set out with no preconceived idea. A few forms suggested here would call for other forms elsewhere to balance them. These in turn demanded others. It seemed interminable. It took a month at least to produce each watercolor, as I would take it up day after day to paint in other tiny spots, stars, washes, infinitesimal dots of color in order finally to achieve a full and complex equilibrium."[49]

Just before the Germans occupied France, it was possible for Miró to flee and regain the safety of his mother country. He continued working on these gouaches in Palma and Montroig. They were generically titled the *Constellations* after the completion of the tenth image in 1940. After this, the resemblance to astronomy maps increased somewhat. *The Beautiful Bird Revealing the Unknown to a Pair of Lovers* (The Museum of Modern Art, New York) uses linear tracery to link the dots defining the strange and amusing creatures staring out of the patterning. Limited areas are painted flatly in green,

"The Civil War meant bombings, death, firing squads, and I wanted to record somehow this very dramatic and tragic period. But I have to admit that I was not aware at that time that I was painting my Guernica.*"*
— JOAN MIRÓ

Constellation: Awakening in the Early Morning, 1941
Gouache and terpentine paint on paper, 46 x 38 cm (18 x 15 in.)
Fort Worth, Texas, Kimbell Art Museum

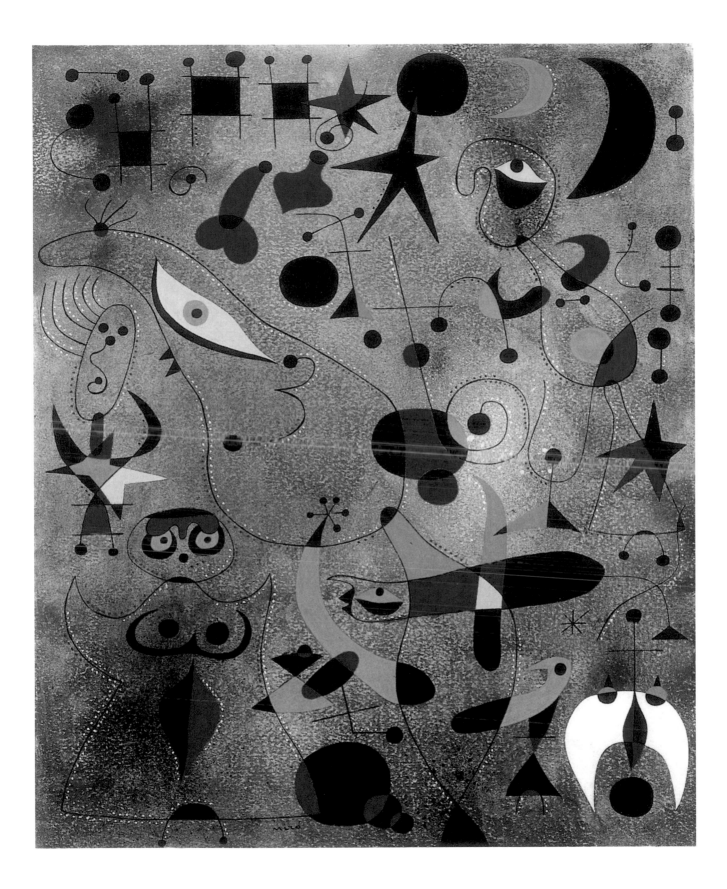

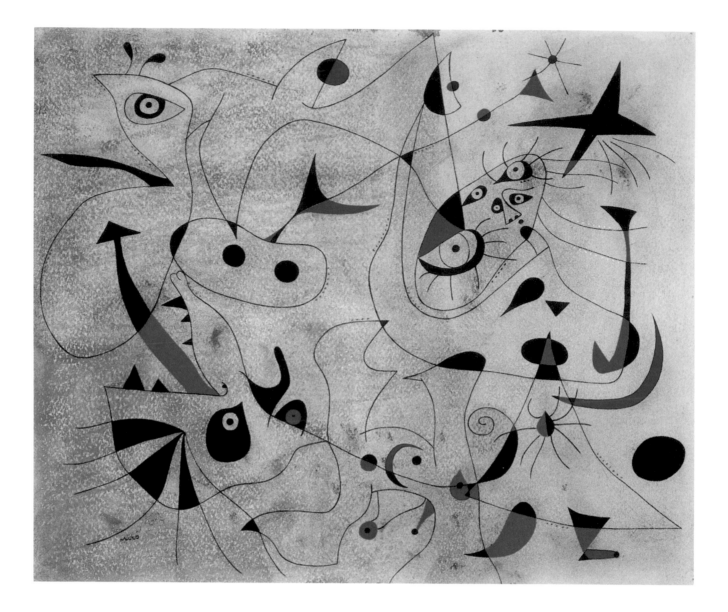

Constellation: The Morning Star, 1940
Gouache and terpentine paint on paper,
38 x 46 cm (15 x 18 in.)
Barcelona, Fundació Joan Miró

yellow, red and blue, however, the black of the dots, some hourglass or bow shapes and the lines dominate, floating clearly above a light surface that has been worked with washes and scratching to bring out its texture. Miró used the Surrealist method of letting the image come to him while working upon the "weathered" painting ground. Still, his source change from reflections on water to the heavens above is interesting. Perhaps he was reading Whitman again, who, in his poem *Bivouac on a Mountain Side* contrasts the view of soldiers camping in a night landscape with the sky above them: "And over all the sky – the sky! Far, far out of reach, studded, breaking out, the eternal stars."

When they were shown in January of 1945, this series of 23 gouaches were the first new European paintings to be shown in New York for some time. Despite their small formats and their being executed on paper, (they had been smuggled into the country in a diplomatic pouch) they made a tremendous impression upon their audience. André Breton wrote the foreword to the catalogue, in which he calls attention to Miró's search for indestructable

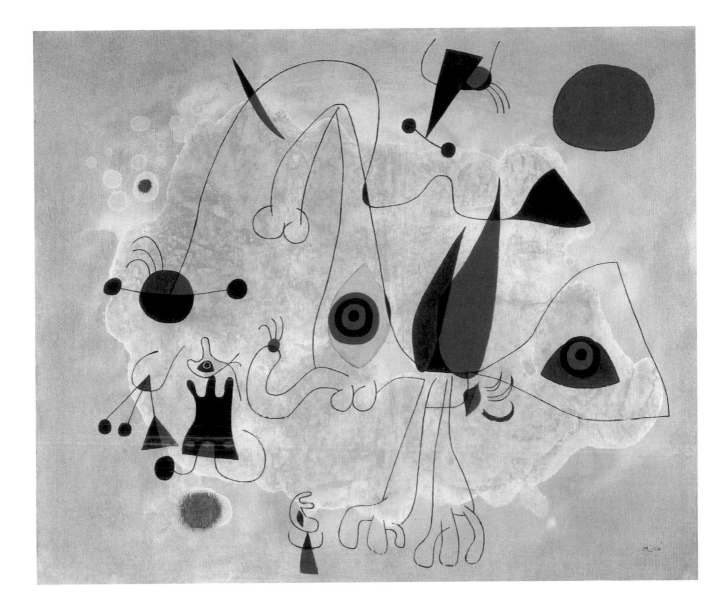

Women and Birds at Sunrise, 1946
Oil on canvas, 54 x 65 cm (21¼ x 25½ in.)
Barcelona, Fundació Joan Miró,
On loan from a private collection

purity during the bitter years of the war. It was as if the art world were thankful that it had been possible for someone to have kept the flame of art alive.

The *Constellations* were to have a profound effect on the New York School of Painting and change the work of such artists as Arshile Gorky and Jackson Pollock. Miró's all-over distribution of forms, the variety of recurring elements, the application of automatic drawing principles and the idea of working in series began to blossom in American painting. These results would, in turn, be taken up in answer by Miró. Of course, the influence of the *Constellations* was not untouched by the success of a major one-man exhibition of Miró's paintings in The Museum of Modern Art in 1941. Despite the war, it had been possible to mount the large show by using works from American collections. The catalogue mentions paintings, drawings, collages, objects, rugs, a tapestry and etchings. It lists Miró's contributions to stage design and book illustration, his prints, exhibitions of his work and a bibliography. Although Miró could not go to New York himself, he had "arrived" there.

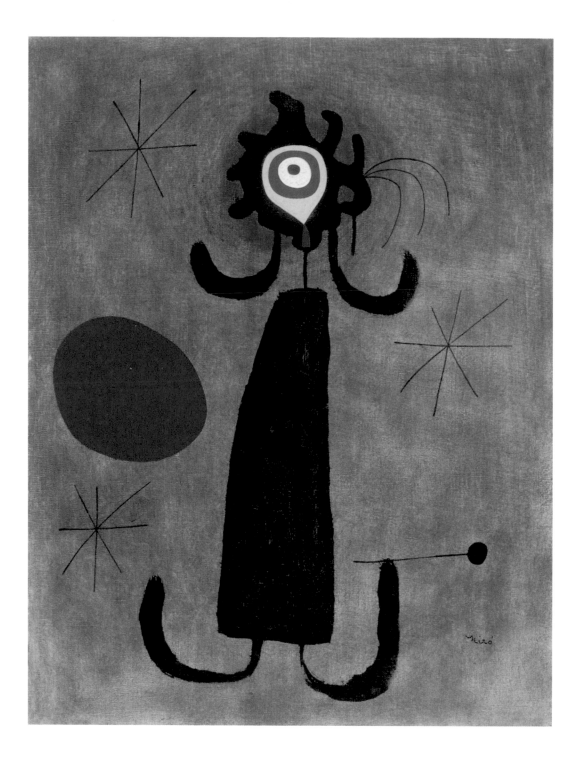

Woman in Front of the Sun, 1950
Oil on canvas, 65 x 50 cm
(25½ x 19¾ in.)
Private collection

PAGE 77
*Ladders Cross the Blue Sky in a
Wheel of Fire,* 1953
Oil on canvas, 116 x 89 cm (45¾ x 35 in.)
Private collection

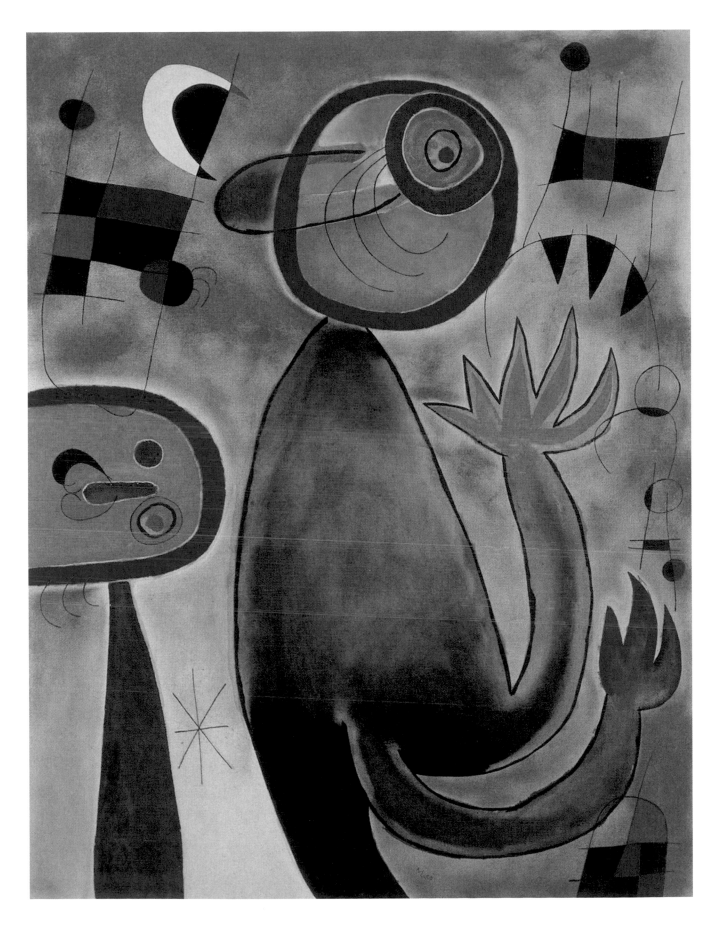

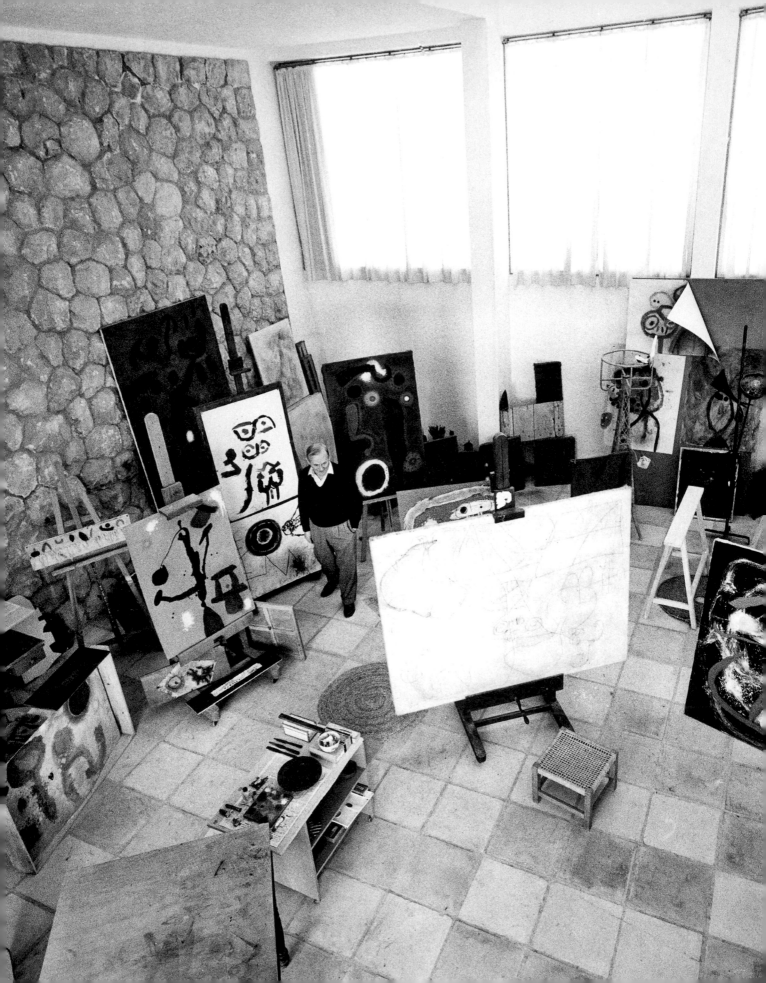

The Dream of a Large Studio

During the war years, Miró had worked to a great extent on paper, because materials were scarce and because paper could be more quickly and easily moved than canvases. He continued using a notebook to write down his ideas for art, so as not to forget them – and there were hundreds. Many of the ideas avoided using conventional art supplies, as if shortages were forcing him in experimental directions and reinforcing his interest in rougher materials. Besides his two-dimensional images, Miró worked with ceramics ("Take earthen jars like the ones from Felanitx and make little turds on them with a pastry tube"), branding irons ("Burn designs into the hides of mules or lambs, like the Indians did") and constructions ("May my sculptures be confused with elements of nature, trees, rocks, roots, mountains, plants, flowers").[50]

Many of the ideas in his notebook open out into the future, foreshadowing developments in Pop and Land Art. Yet the years of uncertainty made Miró worry about ever being able to accomplish enough during his lifetime. He needed more space and, at last, a permanent home. Already in 1938 Miró had a text published in the magazine *XXᵉ Siècle,* in which he voiced his wish for a large studio: "My dream, once I am able to settle down somewhere, is to have a very large studio, not so much for reasons of brightness, northern light, and so on, which I don't care about, but in order to have enough room to hold many canvases, because the more I work the more I want to work. I would like to try my hand at sculpture, pottery, engraving, and have a press, to try also, inasmuch as possible, to go beyond easel painting, which in my opinion has a narrow goal, and to bring myself closer, through painting, to the human masses I have never stopped thinking about."[51]

During the last three decades of his life, Miró was to fulfill this somewhat contradictory wish to go beyond painting while at the same time getting closer to the common people through painting. Although it would remain Miró's main expressive medium, he would begin to take longer excursions away from painting by working with ceramics, printing and sculpture. At the end of the Second World War, Miró was not an ageing survivor disappointed by

Catalan Peasant in the Moonlight, 1968
Acrylic on canvas, 162 x 130 cm (63¾ x 51¼ in.)
Barcelona, Fundació Joan Miró

Miró's later work can be characterized by the simple use of a few pure colors. The pronounced use of black is a new element.

PAGE 78
Joan Miró in his studio in 1960

Miró working on the *Moon Wall* for the UNESCO Building in Paris, *c.* 1955

tragedy, but rather someone impatient to experiment and expand. It is not surprising that Miró should choose the end of the war to mark a turning point in his career. At 52 years of age he decided that he had to finally profit from his art. He wrote polite, yet business-like letters to his gallerists saying clearly, "What I will no longer accept is the mediocre life of a modest little gentleman."[52] Miró was aware that the time had come for him to exhibit and market his art more successfully than ever before. He needed financial success to establish for himself what he considered to be proper working conditions – the large studio – and make his art more and more well known.

In 1947 Miró travelled to the United States for the first time because his gallerist Pierre Matisse had secured a commission for him to execute a wall painting for the new Terrace Plaza Hotel in Cincinnati. A huge painting was needed – 3 meters by 10 meters – and Miró worked on it for nine months in New York before it was shown there and then transported to the hotel for installation. While in New York, Miró often met with his artist friends who had spent their time of exile in the United States, most often perhaps with Marcel Duchamp. To execute the mural Miró used the studio of an American artist named Carl Holty. Holty later wrote an article about artistic creativity, which he published in the *Bulletin of the Atomic Scientists* and which discusses Miró's work on the mural. Holty was initially very disappointed in his encounter with Miró, until he rationalized his problem away.

"When the painting was almost complete and we were looking at it late one afternoon (after darkness made working impossible, for Miró was very orderly and punctilious about the working day), I pointed out certain accidental images of the mind that are bound to emerge uninvited in all complex fields of vision. Miró was not interested in these, nor moved to study

Miró's studio in Palma was built by the architect Josep Lluís Sert. Since December 1992 it has housed a Miró Museum, whose light-flooded rooms still convey the impression that the artist has just gone out for a short moment.

the changes brought about in the painting by the waning daylight when the blues become lighter, the reds and yellows darker, and a painting often resembles a photographic negative of itself. I was surprised that all this meant nothing to him, the more since he told me that (…) he had tried out every manner of producing visual effects. But the real shock of the day came when I pointed to a large white form on the left part of the picture and asked, 'That is a fish, isn't it?' – and he answered somewhat irritably, 'For me it's a woman.' How was it possible that two painters, both of whom had painted non-representational pictures for more than twenty years (and I had once been much influenced by Miró's work), could be so far apart on such an important point? And how could we chide the layman for being so obtuse?

When I hedged a bit on my obvious misinterpretation by suggesting that perhaps he was more interested in the ornamental or decorative use of his 'private' language, he denied this, saying he was not the least interested in decoration or ornament but only in the image. What image then? He was not rigid about composition. While he did not change anything, he certainly added new elements.

One afternoon, after watching some children fly kites on the roof of our studio building, Miró was so inspired by the waving, undulating movements of the kite's tail that he drew those long rhythmic lines into his picture already 'equilibriated' and partially painted and right away without much deliberating. Since the canvas was so much wider than it was high, he drew the

In 1968 Miró designed a large ceramic mural (2 x 12.25 m, 78¾ x 482¼ in.) and labyrinth of sculptures for the Maeght Foundation in Saint-Paul-de-Vence.

"The splendour of the ceramics has guided me: it's like sparks. And then the struggle with the elements: with earth, fire (…) I am definitely a fighter by nature. When you make ceramics, you have to be able to tame the fire."

— JOAN MIRÓ

Sun Wall, 1955–58
Ceramic tiles, 3 x 15 m (118 x 590½ in.)
Paris, UNESCO Building

At the beginning of the nineteen-fifties Miró
and his friend Artigas tested the possibility of
using ceramics in his artistic work. In 1955 Miró
was commissioned to design two long walls out-
side the newly built UNESCO Building in Paris.
As a contrast to the concrete architecture around
them, he designed two ceramic walls in intensive
colors. One of these (ill. below) was dedicated to
the sun, the other to the moon (ill. p. 80).

lines in horizontally in the lower right-hand corner of his painting, the only
place where there was any room left. Surely, wavy lines running from left to
right are not an exact interpretation of the vertical movement of those same
lines leaping and soaring against the sky.

Perhaps the answer to what seemed so mysterious was given by another
artist who came to look at the painting when it was finished. This visitor,
who might have had some prejudices about Miró's work, in the presence
of this painting was moved to say, with considerable emotion, 'It isn't true
that he is a decorator. He is not at all decorative, he creates out of a spirit
of visual wealth and imaginative opulence.' This seemed to establish the
important image Miró created. It was an image of all that is rich and plenti-
ful, singing color, fantasy and poise. The rest, fish or woman, was perhaps a
private matter."[53]

The viewer's ability to react immediately to the sensuality of Miró's paint-
ing has a lot to do with his or her enjoyment of it. (Of course, this also de-
pends on being able to see the images themselves, instead of only reproduc-
tions of them.)

Someone trying too hard to understand Miró's painting may not love it
as much. On the other hand, someone very familiar with Miró's images may
find it hard to keep being thrilled picture after picture, since his repetoire of
forms repeats itself. The art critic Clement Greenberg, who met Miró during
his stay in New York, had reservations about Miró's art, for he considered
it marred by a decorative quality. However, he did feel that Miró had taught
the world a lesson in "color." He decided that Miró's art belonged to the
Grotesque, as it was defined by the nineteenth-century theorist John Ruskin:
"Composed of two elements, one ludicrous, the other fearful." Greenberg
becomes even more specific and classifies it as Ruskin's jesting Grotesque,

since all in all he finds Miró's work more humorous than frightening.[54] Because Miró remained playful, it was difficult for some intellectuals to follow up their initial positive responses with total approval. American artists, however, were quick to respond to Miró's innovative painting techniques and he seems to have had a greater influence on postwar painting in the United States than Picasso.[55]

Another hotel, the Stanhope in New York, also featured a painting by Miró from which several individual motifs were taken and copied onto glasses, ashtrays and coasters. The simple designs, bright colors and black lines leant themselves to this kind of treatment. This quality – loved by some as basic expressiveness and maligned by others as decorativeness – predestined Miró to become an artist for the public space. In addition to painted murals, Miró was asked to design ceramic walls for buildings. During the war, Miró had begun working with his old friend and former fellow student Josep Llorens Artigas, who had become a master ceramicist. He was able to show Miró how to acquire the colors and forms he desired while using the unfamiliar medium. Since Miró insisted on working hand in hand with Artigas (as he did with all the technicians who assisted in his work, be they printers, weavers or foundry workers), he eventually learned a lot about ceramics himself. The medium was important to him as one used in folk art,

LEFT
Fleeing Young Girl, 1968
Painted bronze, 135 x 50 x 35 cm
(53¼ x 19¾ x 13¾ in.)
Private collection

MIDDLE
Woman and Bird, 1967
Painted bronze, 135 x 50 x 42 cm
(53¼ x 19¾ x 16½ in.)
Private collection

RIGHT
His Majesty, 1967/68
Painted bronze, 120 x 30 x 30 cm
(47¼ x 11¾ x 11¾ in.)
Private collection

Miró often made his sculptures from objects and materials he found. He frequently put the parts together as models which were then cast in bronze. Finally he painted them in bright colors: a series of works dating from the end of the nineteen-sixties give the impression of pop personalities.

for example, in the fabrication of the small Majorcan whistles whose whimsical forms inspired both Miró's painted and sculpted creatures. But it was also important to him because it was an earthen medium, belonging to no particular century. While working on a series of objects with Artigas during 1955, Miró was asked to execute two free-standing walls for the UNESCO building in Paris (ills. pp. 80 and 82). Miró, who took the chance to escape from more conventional object-making and immerse ceramics in his painterly imagination, chose the subjects of the sun and the moon. Collaborating with both Artigas and his son, Miró planned the work inspired by cave painting at Altamira, the rough wall of a Catalan Romanesque church and Gaudí's Güell Park in Barcelona, with its mosaic galaxies of sun and moon imagery.

The walls were 3 meters high and 15 and 7.5 meters long. Hundreds of tiles had to be made to fit together to form their surfaces. A first batch of geometrically shaped tiles failed. As Miró wrote, "This unfortunate experience cost us 4,000 kilograms of clay, 250 kilograms of enamel, and 10 tons of wood, not

Constellation, 1971
Bronze, 142 x 130 x 44 cm (56 x 51¼ x 17¼ in.)
Private collection

to speak of the work and time that were wasted." The second attempt with irregularly shaped quadrangular tiles was a success, creating the background upon which Miró was to paint his imagery. He did this "blindly," since the colors appeared only after the tiles were fired. Because some forms had to be done in a single gesture to keep their dynamic expression, Miró painted with a broom made of palm fronds. As he wrote in June/July of 1958: "Artigas held his breath when he saw me grab the broom and begin to trace the five-to six-meter-long motifs, with the good possibility that I would destroy months of work. The last firing took place on May 29, 1958. Thirty-four firings had come before it. We used 25 tons of wood, 4,000 kilograms of clay, 200 kilograms of enamel, and 30 kilograms of colors. So far, we have only seen our work in pieces, spread out on the ground, and have not had a chance to step back from it. That is why we are so anxious and impatient to see the small wall and the big wall go up in the space and the light they were made for."[56]

The dominant *Sun Wall* (ill. p. 82) and the more intimate *Moon Wall* (ill. p. 80) were greeted with much acclaim by critics and public alike. Miró's colors, signs, lines, and his moon and sun shone out upon the Place de Fontenoy in Paris, speaking to passers-by, whether they considered themselves an art public or not. His and Artigas's perfectionism, their insistence on the nuances, irregularities and texturing of the walls paid off. That year Miró was awarded the Guggenheim International Award, which President Eisenhower handed over to him in May 1959. What had begun as an experimental adventure ended as a stellar success. During the nineteen-fifties, Miró bought a house and a piece of land on Majorca, where he had spent part of the war years with his wife's relatives. He commissioned his friend, the architect Josep Lluís Sert, to build him the large studio he wanted. The move to the new studio in 1956 meant consolidating his belongings, reviewing his ideas and destroying or overpainting things he felt were not worth keeping. The beautiful new space opened up many possibilities for Miró, who continued to work almost incessantly in a disciplined fashion. He travelled to Paris, worked with Artigas on ceramic projects, and went to the Maeght Foundation in Saint-Paul-de-Vence and to Barcelona to execute series of prints. The prints were important to Miró, since they were much less expensive than his paintings and brought his imagery into wide circulation independent of a museum context. It was one way of "reaching the people." He also began to make sculptures on a greater scale, which were sometimes cast in bronze at foundries in Barcelona and Paris. Sculpture appears to have taken Miró back to "things," back to the individual blades of grass, the insects, the rocks, the toys and the chance found items that he had always collected because they seemed meaningful to him. Miró made models for sculpture out of found materials, which could be either man-made, like a hat blowing along a beach, or natural, like a pebble.

In 1953 Artigas's son assumed the task of translating these constructions into clay. Miró sometimes amended them. Besides such ceramic objects, Miró conceived sculptures that were cast in bronze from modelled ceramic forms. Other works were cast directly from constructed objects. The bronze

Personage, 1970
Bronze, 200 x 120 x 100 cm
(78¾ x 47¼ x 39¼ in.)
Private collection

Miró's bronze sculptures are often reminiscent of the older sculptor Alberto Giacometti. Other works like this female *Personage* seem to have just emerged from one of Miró's paintings.

Blue II, 1961
Oil on canvas, 270 x 355 cm (106¼ x 139¾ in.)
Paris, Musée national d'art moderne,
Centre Georges Pompidou

The two pictures on these pages are part of a
triptych which Miró produced as a reaction to
his second trip to America. He had been deeply
influenced by Abstract Expressionism.

figures might or might not then be painted. Usually no or only very minor
plinths lifted the sculptures up and away from the terrain of the viewer.

Miró's sculpture has many faces. During the late nineteen-sixties, he made
a great number of surprisingly fresh-looking sculptures whose humorous
mixture of objects and bright coloring made them into engaging pop per-
sonalities: *The Fleeing Young Girl, Woman and Bird* or *His Majesty* (ills. p. 83)
do not look as if they could possibly be the work of a seventy-five-year-old
man. Other pieces, such as *Insect Woman* (1968), echo the sculpture of an
older artist, Alberto Giacometti, in their rough surfaces and verticality. Still
others, like *Solar Bird* and *Lunar Bird* (1968; Fondation Maeght, Saint-Paul-
de-Vence) or *Figure*, 1974, seem to be monumental tributes to Majorcan folk
art, particularly to the small handmade and painted ceramic whistles called
"siurells," which Miró collected as early as the nineteen-twenties.[57] And of
course, some, such as the *Personage* (ill. p. 85) or the *Constellation* (ill. p. 84)
could have stepped out of a painting by Miró himself. The sculpture park
with labyrinth in Saint-Paul-de-Vence might be the best place to see all
types of Miró's sculpture in the place he liked it shown the best: outdoors.
In 1962 Miró said, "All good sculpture should look immense in the open air.

Moreover, I leave my sculptures outside. The sun, the wind, the rain, even dust improves them. Also, I often take my paintings outside to see if they hold up, to assess them."[58]

During the early nineteen-sixties, Miró's paintings became emptier again, to the point where they resembled some of his work from 1925, when he executed almost monochrome canvases with only a few emphatic accents. One of several large triptychs, *Blue I–III* (ills. pp. 86 and 87), shows both clearly delineated and indistinct black and red forms against a bright blue field. The viewer is tempted to read the three canvases as the flying-saucer-like appearing and disappearing of the red bar. Time, space, orbits, but also microcosms invisible to the eye suggest themselves. Miró produced the three paintings, which were sold individually, under the influence of his second trip to America. Pollock's Action Paintings and the Abstract Expressionism of Robert Motherwell and Mark Rothko had made a deep impression on him. Nevertheless Miró's forms are not of an abstract nature, even at their most reduced. They always remain endebted to nature which has inspired them.

Over ten years later in 1973, he painted *May 1968* (ill. p. 91), a delayed reference to the student revolution in Paris. It, too, recombines and recharges

Blue III, 1961
Oil on canvas, 268 x 349 cm (105½ x 137½ in.)
Paris, Musée national d'art moderne,
Centre Georges Pompidou

Joan Miró commented on these works:
"It is important for me to achieve a maximum of intensity with a minimum of effort. That is why the empty spaces in my pictures gain increasingly in significance."

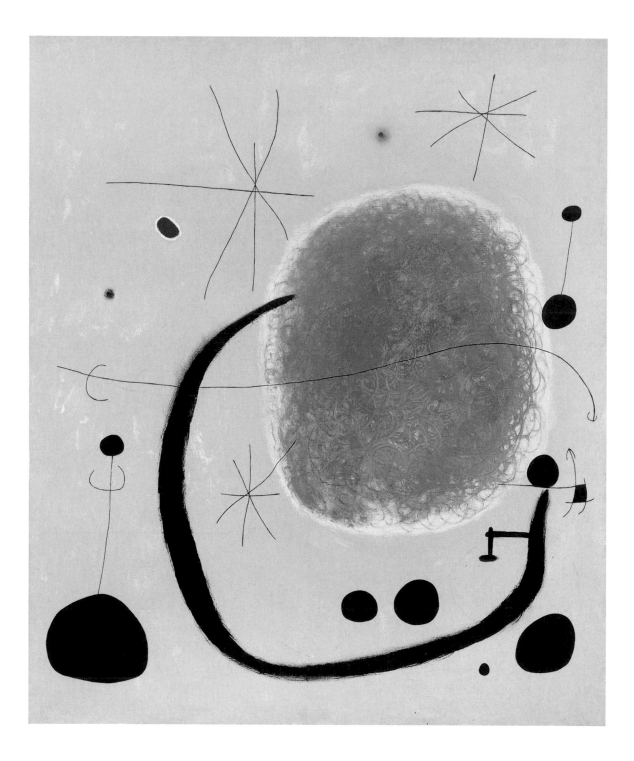

The Gold of the Azure, 1967
Oil on canvas, 205 x 173 cm
(80¾ x 68 in.)
Barcelona, Fundació Joan Miró

PAGE 89
*The Lark's Wing, Encircled with Golden Blue,
Rejoins the Heart of the Poppy Sleeping on a
Diamond-Studded Meadow,* 1967
Oil on canvas, 195 x 130 cm (76¾ x 51¼ in.)
Private collection

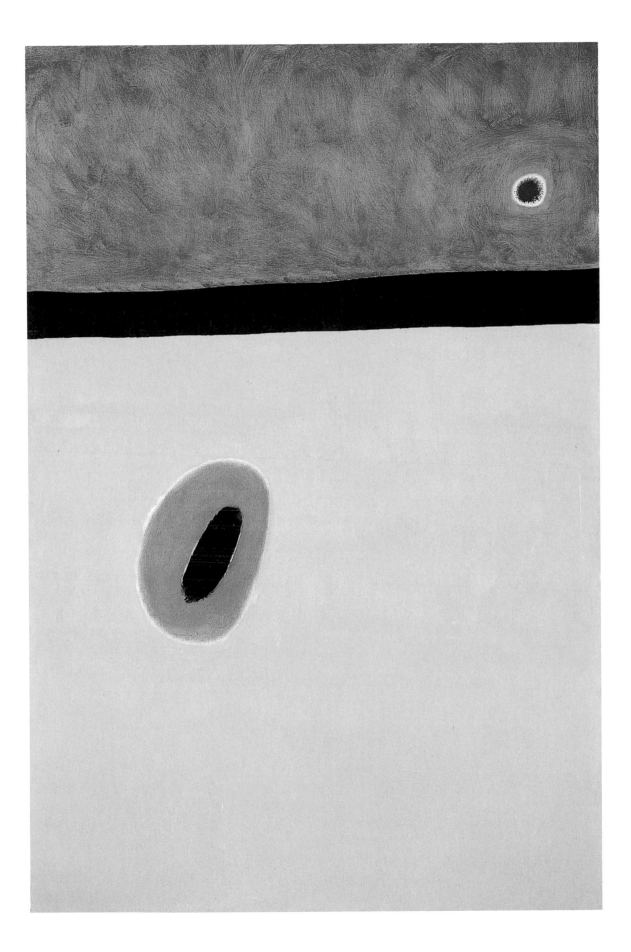

spontaneous gestures and deliberate signs and comes up with a painting that looks as if it could have been done during the nineteen-eighties. At almost the same time, however, *Woman with three Hairs Surrounded by Birds in the Night,* 1972, harkens back to Miró's idiom of the mid-nineteen-twenties and thirties, even though the woman's skirt has a regular ornamental patterning that conforms only to more modern design. Miró was flexible in his imagery, reaching across time for appropriate impulses and inspiration.

Miró had a colossal output. During his 90 years he made at least 2,000 oil paintings, 500 sculptures, 400 ceramic objects, and 5,000 drawings and collages. Using lithography, etching and other graphic techniques he created about 3,500 images, which were mostly published in editions of fifty to seventy-five. And all of them contain something of Miró's Catalan home, expressed by the language he developed in time, always growing from his roots there.

In 1936, Miró wrote, "Today, my young contemporaries know how to struggle when they are poor, but all that stops the moment they balance their budgets. Compared to these people who begin their shameful decline at the

Figures, Birds, Star, 1978
Acrylic on canvas, 89 x 116 cm (35 x 45¾ in.)
Barcelona, Fundació Joan Miró

Miró once again intimates the elements that characterized many of his paintings. His later work adds a new quality to his world of signs, a far cry from the joyful figures of the previous years.

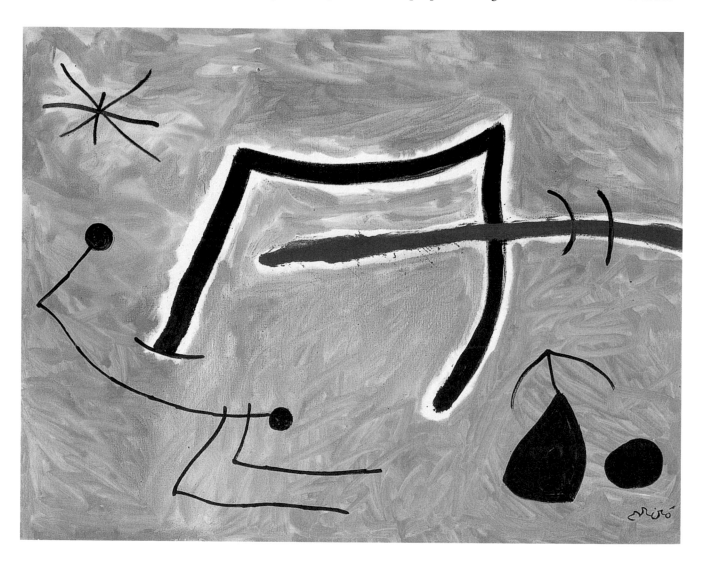

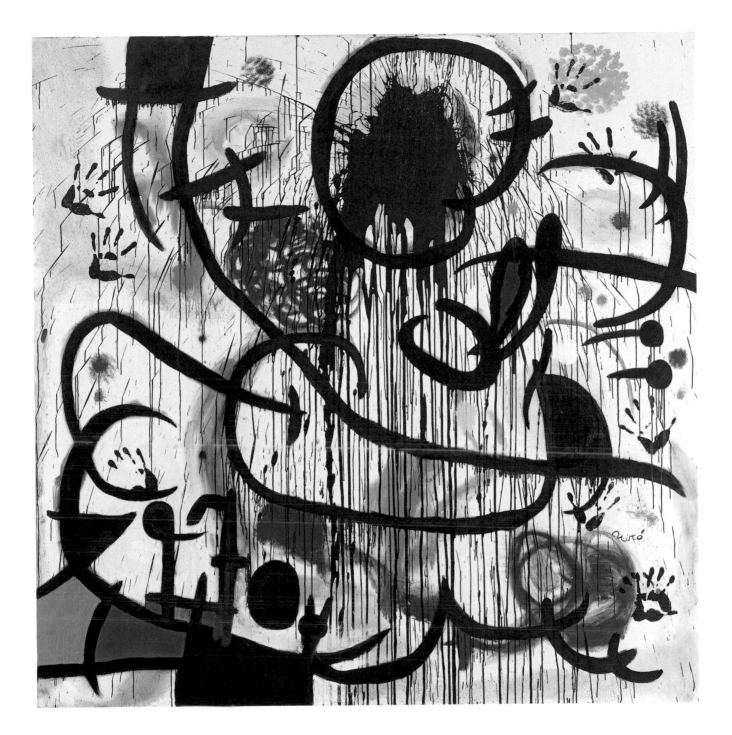

age of thirty, how much I admire artists like Bonnard or Maillol. These two will continue to struggle until their last breath. Each year of their old age marks a new birth. The great ones develop and grow as they get older."[59] Obviously Miró had disciplined himself into becoming just such an artist who would struggle, learn and develop as long as he lived, without compromising his own style. He would continue to make vibrant art without worrying about its contemporary correctness. The railway sign that Miró had once found in a shop and hung on his studio door in Paris because it had so appealed to him was quite correct: "THIS TRAIN MAKES NO STOPS."

May 1968, 1973
Acrylic on canvas, 200 x 200 cm
(78¾ x 78¾ in.)
Barcelona, Fundació Joan Miró

The picture gives the impression of an obituary notice for the student protests of May 1968. The traces of the paint thrown at the picture, the contours of Miró's hands and the stunning colorfulness of the picture give no hint that he painted this at the age of eighty.

Joan Miró
1893–1983
Life and Work

1893 April 20: Joan Miró Ferra born in Barcelona. Miró's father was a goldsmith and watchmaker, his mother the daughter of a cabinetmaker.

1897 May 2: Joan Miró's only sister, Dolores, born in Barcelona.

1900 Begins schooling and has first drawing lessons. Now spends the summers with paternal grandparents in Cornudella (province of Tarragona) and with maternal grandmother in Majorca.

1907 Miró's father persuades him to take business classes, which he attends dutifully. However he also has art instruction at the renowned academy La Escuela de la Lonja. His teachers were Modesto Urgell Inglada, a landscapist, and José Pasco Merisa, professor of decorative arts.

1910–11 Works as a bookkeeper for a hardware and chemical company. Illness and breakdown convince father that Miró is unsuited for business. Purchase of family farm in Montroig (province of Tarragona).

1912 Barcelona, April 20– May 10: Exhibition of Cubist painting at the gallery Dalmau, with paintings by Duchamp, Gleizes, Gris, Laurencin, Le Fauconnier, Léger and Metzinger. Begins studies with Francesc d'Assís Galí Fabra (until 1915). Meets Josep Llorens Artigas, Enric C. Ricart Nin and Josep F. Ràfols Fontanals, with whom he will remain friends for the rest of his life.

1913 Enrolls in the "Cercle Artistic de Sant Lluc" for drawing classes (until 1918). Shows three paintings in an exhibition of the Sant Lluc circle.

1914 Rents studio with Ricart.

1915 From October to December fulfills required military service (every year through 1917).

1916 Gets to know art dealer Josep Dalmau.

1917 Dalmau introduces Miró to Picabia. Reads Apollinaire's poetry during final military service.

1918 First one-man exhibition at Dalmau's gallery (64 paintings and drawings). Founds "Agrupado Courbet" together with other artists.

1920 Early March: Miró's first trip to Paris. Visits museums and Picasso's studio. Draws at the Académie Chaumière. Attends Dada festival, Salle Gaveau. Has three paintings included in Dalmau's show "Avant-Garde French Art" along with works by Picasso, Severini, Signac, Metzinger, Laurencin, Matisse, Gris, Braque, Cross, Dufy, Van Dongen and others. Catalan art show in Paris exhibits two paintings of his.

1921 Second trip to Paris. Paints in a studio rented to him by Catalan sculptor Pablo Gargallo at 45 Rue Blomet, where André Masson is his neighbor. First one-man exhibition in Paris, organized by Dalmau.

1922 *The Farm* is shown at the Salon d'Automne in November–December.

1924 Miró meets Paul Éluard, André Breton and Louis Aragon. "First Surrealist Manifesto" published.

1925 First one-man exhibition at Galérie Pierre. Impressed by Paul Klee's work at an exhibition in Paris. November: exhibits in "La Peinture Surréaliste" at the Galérie Pierre and is invited to the Surrealist banquet for the French poet Saint-Pol-Roux.

1926 Max Ernst and Miró work on the set of the Ballets Russes production of "Romeo and Juliet." Death of Miró's father at Montroig. Has two paintings in "Exhibition of International Modern Art" in Brooklyn, New York.

Joan Miró at the age of 18 months

PAGE 92
Joan Miró with an *objet trouvé*, Montroig, 1954

1927 Miró moves to Cité des Fusains, with neighbors Max Ernst, Jean Arp, Pierre Bonnard and others.

1928 Trips to Holland and Belgium. First trip to Madrid. Meets Alexander Calder in Paris.

1929 October: Marries Pilar Juncosa in Palma de Majorca. Returns to Paris and moves to Rue François Mouthon.

1930 Several one-man exhibitions in Paris. Included in "La peinture au défi" at Galérie Goemans. Birth of only child, a daughter,

Dolores, in Barcelona. First one-man show in the United States, Valentine Gallery, New York. Included in exhibition of paintings with Masson, Ernst, and Man Ray on the occasion of the premiere of Luis Buñuel's "L'Âge d'Or" in Paris. Exhibited works attacked by right-wing demonstrators. First lithographs for Tzara's "L'Arbre des voyageurs." Becomes acquainted with the gallerist Pierre Matisse.

1932 Miró moves back into the home of his childhood, living and working on the top floor. There he designs costumes, sets and props for the Ballets Russes de Monte Carlo production of "Jeux d'enfants".

1933 Meets Wassily Kandinsky.

1936 Outbreak of Spanish Civil War. Visits to London and Paris, where he is caught in November by political developments in Spain. His family must join him there in December. First monograph on Miró published, published by Shuzo Takiguchi (in Japanese).

1937 Paints *The Reaper* (now lost) for Spanish republican pavilion, Paris World Fair. From November to January, Miró and his daughter Dolores sit for portrait by Balthus.

1938 Because he cannot go to Montroig, Miró spends summer in Varengeville-sur-Mer, Normandy, in house lent to him by the architect Paul Nelson. Paints fresco *Birth of the Dolphin* on the living-room walls.

1939 Paris. January: Franco's troops occupy Barcelona. Rents Villa "Clos des Sansonnets" in Varengeville.

1940 Friendly with Georges Braque. Begins series of gouaches *Constellations*.

1941 First large retrospective show, The Museum of Modern Art, New York; organization and catalogue by James Johnson Sweeney.

1944 Miró's mother dies. First ceramic works with Llorens Artigas and first bronze sculptures.

1946 "Four Spaniards" exhibition in Boston, Institute of Contemporary Art with Dalí, Gris, and Picasso.

1947 First visit to the United States to execute mural for Cincinnati Terrace Hilton Hotel. Works on it during nine months in New York in the studio of Carl Holty. Thomas Bouchard films him painting. Meets Clement Greenberg and Jackson Pollock. Asked to illustrate Paul Éluard's "À toute épreuve." Does illustration for Tristan Tzara's "Antitête."

1950 Paints mural for Harkness Graduate Center dining room at Harvard University, Cambridge, commissioned by Walter Gropius.

1952 Miró visits Paris and sees Jackson Pollock exhibition. Retrospective show in the Kunsthalle Basel.

1953 Starts work in Gallifa with Llorens Artigas on large series of ceramics.

1954 Venice Biennial, grand prize for graphic work.

1955 Invited to do two walls for UNESCO headquarters, Paris. Included in the "documenta I," Kassel.

1956 Miró moves to Palma de Majorca into villa designed by his friend Josep Lluís Sert. Sells his childhood home in Barcelona. Begins work on ceramic mural for UNESCO Building.

1957 Miró goes to Altamira to see cave paintings with Artigas as inspiration for UNESCO walls. Begins work with Jacques Dupin on major monograph.

1958 Completes UNESCO walls.

1959 Retrospective show, New York, which travels to Los Angeles. Miró makes second

TOP LEFT
Miró amongst a group of students from Francesc Galí's academy, *c.* 1913 (3rd from left)

TOP RIGHT
Joan Miró (2nd from left) and Jean Arp (sitting), 1927

RIGHT
Miró and his friend Yvo Pascual in front of the silhouette of the village of Prades, 1917

PAGE 95 TOP
Miró in his Paris studio in the Rue François Mouthon, 1931

PAGE 95 BOTTOM
Miró at work designing a frieze, *c.* 1958

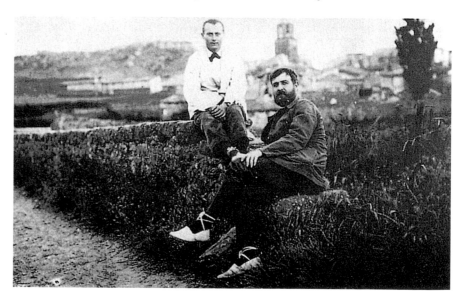

trip to the United States. Included in the "documenta II". Given Guggenheim International Award for UNESCO walls.

1960 Artigas and Miró work on ceramic wall to replace mural in Harvard Harkness Center dining room. Wall shown in Barcelona, Paris and New York before it is installed in building (1961).

1964 Inauguration of Fondation Maeght, Saint-Paul-de-Vence, with sculptures and labyrinth by Miró. With Artigas executes ceramic mural for École Supérieure de Sciences économiques, St. Gall, Switzerland. Included in "documenta III".

1966 Artigas and Miró execute underwater ceramic sculpture *Venus of the Sea* for grotto, Juan-les-Pins. Retrospective, National Museum of Modern Art, Tokyo, also shown in Kyoto. First trip to Japan. First monumental bronze sculptures.

1968 Honorary Degree, Harvard University. Fifth and final trip to the United States.

1970 Large ceramic mural executed with Artigas for the airport in Barcelona. Three monumental ceramic murals and water garden for the glass pavilion, World Fair, Osaka.

1975 Unofficial opening of Fundació Joan Miró – Centre d'Estudis d'Art Contemporani, Barcelona. Death of Franco.

1976 Official inauguration of Fundació Miró. Design for pavement "Pía de Os"; ceramic mural for IBM Laboratories, Barcelona. Ceramic mural for Wilhelm-Hack Museum, Ludwigshafen.

1978 Catalan theater piece "Mori el Merma" shown in European capitals. Retrospective exhibitions in Museo Español de Arte Contemporáneo, Madrid, and Sa Llotja, Palma de Majorca. Retrospective of prints, Madrid. Two exhibitions

of drawings, sculptures in Paris. Monumental sculpture for La Défense, Paris.

1980 Exhibition "Joan Miró: The Development of a Sign Language," Washington University Gallery of Art, St. Louis (also shown in Chicago). Retrospective exhibitions at Joseph Hirshhorn Museum and Sculpture Garden, Washington, D.C. (also shown in Buffalo, New York) and Museo de Arte Moderno, Mexico City, which travels to Caracas. Ceramic mural for Palacio de Congreso y Exposiciones, Madrid.

1981 Unveiling of monumental sculpture *Miss Chicago*, in Chicago. Costumes, sets for ballet "Miró l'Uccello Luce," Venice. Unveiling of two monumental sculptures in Palma de Majorca.

1982 Unveiling of monumental sculpture *Personnage et Oiseaux*, Houston. Retrospective exhibition, Fundació Joan Miró, Barcelona. Unveiling of monumental sculpture *Dona i ocell (Woman and Bird)* in the Parc Joan Miró in Barcelona.

1983 Unveiling of monumental sculpture in patio of government building, Barcelona. December 25: Death of Joan Miró at Palma de Majorca. Buried in family vault, Montjuic Cemetery, Barcelona.

1992 Opening of the exhibition building of the Fundación Miró in Palma de Majorca which was planned by Rafael Moneo.

Photo credits

The publisher would like to thank the picture archives, photographers, museums and owners for their contributions on the following pages:

akg-images: 17, 19, 36, 61; akg-images / Nimatallah: 40–41; Album/Oronoz / akg-images: 51; Photography © The Art Institute of Chicago: 54; © Foto CNAC / MNAM Dist. RMN / Philippe Migeat: front cover, 86, 87; © Christie's Images / Bridgeman Images: back cover; Fundació Joan Miró, Barcelona: 65, 70, 88, 91; INTERFOTO: 66; Kunstmuseum Bern: 56; © Archives Foundation Maeght, Saint-Paul, Photo © Claude Germain: 81; © Mary and Leigh Block Museum of Art: 84; National Gallery, Prague: 57; © 2016. The Museum of Modern Art, New York / Scala, Florence: 11, 32, 33, 34, 39, 46, 52, 62, 64, 67; National Gallery of Art, Washington: 31; Philadelphia Museum of Art: 47; Solomon R. Guggenheim Museum, New York: 14; Courtesy Successió Miró, Palma de Mallorca: 12, 20, 50, 75, 83 left, 83 center, 83 right / 78 (Photo © Bert van Bork) / 80 bottom (Photo © Joaquim Gomis) / 92 (Photo © Fran-cesca Català-Roca) / 95 (© Thérèse Bonney); © The University of Iowa Museum of Art: 68; Collection Van Abbe Museum, Eindhoven © Peter Cox: 63

Notes

1 See letter to Jacques Dupin from Miró about his childhood, in Joan Miró, *Selected Writings and Interviews*, edited by Margit Rowell, London, 1987 (Referred to in all following footnotes as "Rowell"), pp. 44–45

2 Ibid.

3 Ibid.

4 Ibid.

5 Miró, letter to Michel Leiris, September 25, 1929, Rowell, p. 110

6 See note 5 and also Miró in an interview with James Johnson Sweeney, *Partisan Review*, February 1948, in Rowell, pp. 207–211, here p. 208

7 Galí, quoted from Jacques Dupin, *Joan Miró: Life and Work*, New York, 1960 (Referred to in the following footnotes as "Dupin")

8 See note 1

9 See Robert S. Lubar, "Miró's katalanische Anfänge," in *Joan Miró*, catalogue Kunsthaus Zürich and Städtische Kunsthalle Düsseldorf, 1986, p. 15

10 Miró, letter to E. C. Ricart, Barcelona, October 7, 1916, in Rowell, p. 49

11 Miró, quoted from R.S. Lubar, see note 9, p. 16

12 See Walther L. Bernecker, *Sozialgeschichte Spaniens im 19. und 20. Jahrhundert*, Frankfurt on the Main, 1990, p. 233

13 Miró, letter to E. C. Ricart, Barcelona, October 1, 1917, in Rowell, pp. 52–53

14 Miró, letter to E. C. Ricart, Barcelona, May 11, 1918, in Rowell, p. 53

15 Ibid.

16 Miró, letter to E. C. Ricart, Montroig, July 16, 1918, in Rowell, p. 54

17 Miró, letter to J. F. Ràfols, Montroig, August 11, 1918, in Rowell, p. 57. In a letter to E. C. Ricart from Montroig, July 9, 1919, Miró indirectly compares himself to Walt Whitman.

18 Miró, letters to E. C. Ricart, Montroig, September 14, 1919 and probably November 1919, in Rowell, pp. 64 and 65

19 Miró, letter to J. F. Ràfols, Montroig, July 25, 1920, in Rowell, p. 74

20 Miró, letter to J. F. Ràfols, Barcelona, November 18, 1920, in Rowell, p. 75

21 Miró, letter to J.F. Ràfols, Paris, Hotel de Rouen, perhaps March 1920, in Rowell, p. 71

22 Miró, "Memories of the Rue Blomet," transcribed by Jacques Dupin, 1977, in Rowell, pp. 100–101

23 Ibid., p. 101

24 Francesc Trabal, "A Conversation with Joan Miró," Barcelona, 1928, in Rowell pp. 92–93

25 Ibid., p. 93

26 Ibid.

27 Miró, quoted from Lluís Permanyer, "Revelations by Joan Miró about His Work," in *Gaceta Ilustrada*, Madrid, April 1978, in Rowell, p. 290

28 See R. S. Lubar, cf. note 9, p. 12

29 Gaudí, quoted from Gabriele Sterner, *Barcelona: Antoni Gaudí, Architektur als Ereignis*, Cologne, 1979, this author's translation, p. 9

30 See James Johnson Sweeney interview with Miró, in *Partisan Review*, New York, February 1948, in Rowell, pp. 207–211, here p. 207

31 See Clement Greenberg, *Joan Miró*, New York, 1948, p. 38

32 Miró, quoted from Gaétan Picon, *Joan Miró: Catalan Notebooks, Unpublished Drawings and Writings*, New York, 1977, p. 128

33 See Rosalind Krauss and Margit Rowell, *Magnetic Fields*, The Solomon R. Guggenheim Foundation, New York, 1972, p. 74

34 Miró, letter to Roland Tual, Montroig, July 31, 1922, in Rowell, p. 79

35 See note 19

36 Miró, see note 32, pp. 72–73

37 See note 34

38 "Surrealist Manifesto," in *Dada, Surrealism and Their Heritage*, edited by William S. Rubin, New York, 1968, p. 64

39 See *Miró in the Collection of the Museum of Modern Art*, edited by William S. Rubin, New York, 1973, p. 33

40 Miró, letter to Michel Leiris, Montroig, October 31, 1924, in Rowell, p. 87

41 Ibid.

42 See Dupin, p. 179

43 See Dupin, p. 239

44 Miró, letter to Sebastià Gasch, Monte Carlo, probably March–April 1932, in Rowell, p. 119

45 See note 39, p. 64

46 Rowell, p. 136

47 Miró, letter to Pierre Matisse, Paris, Hotel Récamier, January 12, 1937, in Rowell, p. 146

48 Ibid., pp. 146–148

49 See note 30, pp. 209–211

50 See Rowell, pp. 175–195

51 Miró, "I dream of a Large Studio," in *XXᵉ Siècle*, Paris, May 1938, in Rowell, pp. 161–162

52 Miró, letter to Pierre Loeb, Montroig, August 30, 1945, in Rowell, pp. 197–198

53 Carl Holty, "Artistic Creativity," in *Bulletin of the Atomic Scientists*, volume 2, February 1959, pp. 77–81

54 See note 31, p. 31

55 See Barbara Rose, "Miró aus amerikanischer Sicht," in *Joan Miró*, see note 9, pp. 103–142

56 Miró, "My Latest Work Is a Wall," in *Derrière Le Miroir*, Paris, June–July 1958, in Rowell, pp. 242–245

57 See Nicholas Watkins, "Miró and the 'siurells'," in *The Burlington Magazine*, London, volume 132, fall 1990, pp. 90–95

58 Miró, Interview "Miró" by Denis Chevalier, in *Aujourd'hui Art et Architecture*, Paris, November 1962, in Rowell, pp. 262–271

59 Miró, Interview, "Where Are You Going, Miró?" by Georges Duthuit, in *Cahiers d'Art*, Paris, nos. 8–10, 1936, in Rowell, pp. 150–155, here p. 150

The author

Janis Mink studied art history at Smith College and gained her doctorate in Hamburg under Martin Warnke. She is presently a writer and curator.

Imprint

EACH AND EVERY TASCHEN BOOK PLANTS A SEED!
TASCHEN is a carbon neutral publisher. Each year, we offset our annual carbon emissions with carbon credits at the Instituto Terra, a reforestation program in Minas Gerais, Brazil, founded by Lélia and Sebastião Salgado. To find out more about this ecological partnership, please check: www.taschen.com/zerocarbon
Inspiration: unlimited.
Carbon footprint: zero.

To stay informed about TASCHEN and our upcoming titles, please subscribe to our free magazine at www.taschen.com/magazine, follow us on Instagram and Facebook, or e-mail your questions to contact@taschen.com.

© 2022 TASCHEN GmbH
Hohenzollernring 53, D–50672 Köln
www.taschen.com

Original edition:
© 1993 Benedikt Taschen Verlag GmbH

© for the works of Joan Miró:
Successió Miró/VG Bild-Kunst, Bonn 2022

© for the work of Man Ray:
Man Ray 2015 Trust/VG Bild-Kunst, Bonn 2022

Printed in Slovakia
ISBN 978-3-8365-2923-5

FRONT COVER
Blue II (detail), 1961
Oil on canvas, 270 x 355 cm (106¼ x 139¾ in.)
Paris, Musée national d'art moderne, Centre Georges Pompidou

PAGE 2
Joan Miró working on a drawing, *c.* 1958
Photograph by Walter Erben

PAGE 4
Dancer II, 1925
Oil on canvas, 115.5 x 88.5 cm (45½ x 35 in.)
Lucerne, Galerie Rosengart

BACK COVER
Joan Miró, 1947
Photograph by George Platt Lynes